Fill Your **OIL PAINTINGS** *with* **LIGHT & COLOR**

FILL YOUR
Oil Paintings
WITH
Light & Color

KEVIN D. MACPHERSON

NORTH LIGHT BOOKS
Cincinnati, Ohio

DEDICATION
I dedicate this book to my wife and soul mate, Wanda.

ACKNOWLEDGMENTS
I appreciate the many students throughout the country who have inspired me to put my ideas on paper, and the support of all my collectors, who help me continue on my artistic journey.

Acknowledging my wife, Wanda, goes without saying. She has always backed my career efforts. She has photographed all my paintings and step-by-step demonstrations. Deciphering my handwritten script for computer input was not an easy task, but she did it with a smile and still loves me.

My friend Chuck Sovek was very encouraging and was always there with advice. I appreciate the photographic skills of my good friend Rick Raymond. He photographed my portrait, setups and hands-on shots.

Don Holden deserves a thank-you for recommending me to Greg Albert at North Light Books. Special thanks go to my editors Rachel Wolf and Pamela Seyring. I appreciate their faith, patience and direction while putting this all together.

Fill Your Oil Paintings With Light and Color. Copyright © 1997 by Kevin D. Macpherson. Printed and bound in China. All rights reserved. No part of this book may be reproduced in any form or by any electronic or mechanical means including information storage and retrieval systems without permission in writing from the publisher, except by a reviewer, who may quote brief passages in a review. Published by North Light Books, an imprint of F&W Publications, Inc., 1507 Dana Avenue, Cincinnati, Ohio 45207. (800) 289-0963. First edition.

Other fine North Light Books are available from your local bookstore, art supply store or direct from the publisher.

01 00 99 5 4 3

Library of Congress Cataloging-in-Publication Data

Macpherson, Kevin D.
 Fill your oil paintings with light and color / Kevin D. Macpherson.
 p. cm.
 Includes bibliographical references and index.
 ISBN 0-89134-687-2 (hc : alk. paper)
 1. Light in art. 2. Color in art. 3. Painting—Technique.
 I. Title.
ND1484.M23 1996
751.45—dc20 96-25743
 CIP

Edited by Pamela Seyring
Designed by Brian Roeth

METRIC CONVERSION CHART		
TO CONVERT	**TO**	**MULTIPLY BY**
Inches	Centimeters	2.54
Centimeters	Inches	0.4
Feet	Centimeters	30.5
Centimeters	Feet	0.03
Yards	Meters	0.9
Meters	Yards	1.1
Sq. Inches	Sq. Centimeters	6.45
Sq. Centimeters	Sq. Inches	0.16
Sq. Feet	Sq. Meters	0.09
Sq. Meters	Sq. Feet	10.8
Sq. Yards	Sq. Meters	0.8
Sq. Meters	Sq. Yards	1.2
Pounds	Kilograms	0.45
Kilograms	Pounds	2.2
Ounces	Grams	28.4
Grams	Ounces	0.04

ABOUT THE AUTHOR

Kevin Macpherson, a popular painter and teacher, has mastered the art of painting outdoors directly from nature, *en plein air*, to quickly and spontaneously capture the true effects of color and light.

Kevin displayed an artistic passion from his earliest days growing up in New Jersey, and was honored with his first art award as a second-grader. Although art has always been the focus of his life, he was not formally trained until attending Northern Arizona University. After graduating with a Bachelor of Fine Arts, he began a successful career as an illustrator in Phoenix.

Kevin married his college sweetheart, Wanda, a year later. The two of them took to traveling the British Isles for six months, and Kevin paid their way with small watercolor sketches, his preview to painting *en plein air*. On returning to the United States, the couple settled in Scottsdale, Arizona, where Kevin resumed freelance illustration for major American corporations while attending classes at the Scottsdale Artists' School. There he had the opportunity to study with some of the best representational painters in the country.

Kevin eventually became a regular instructor at the Scottsdale Artists' School, where he still teaches. He and Wanda now live in the mountains east of Taos, New Mexico, where he pursues his fine art full time.

Kevin is a founding member of the prestigious Plein Air Painters of America, and an Honorary Member of the Oil Painters of America. His work is represented by galleries in Arizona, New Mexico, California, Wyoming and Texas.

Macpherson regularly participates in many national shows, taking top honors. He has won several important awards from the Oil Painters of America, 1992-1995; Art for the Parks Top 200, 1992, 1995; and top awards in *The Artist's Magazine* Competition. His work has been featured in national periodicals such as *Who's Who in American Art*, *Art of the West*, *Art Talk*, *Southwest Art* and *The Artist's Magazine*.

Kevin credits his schooling, relationships with many fine artists, and his work as an illustrator as integral parts of his artistic development. A teacher in great demand, he believes in giving back by helping other artists who are willing to learn. He is a judge, demonstrator and workshop instructor for art guilds throughout the United States and abroad.

Wanda and Kevin keep their bags packed and their R.V. ready to roll. Their travels have taken them in search of new vistas in every corner of the United States, as well as on many foreign soils. Wanda, who is also learning to paint, handles Kevin's business affairs, photography and promotion.

Table of Contents

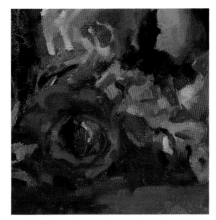

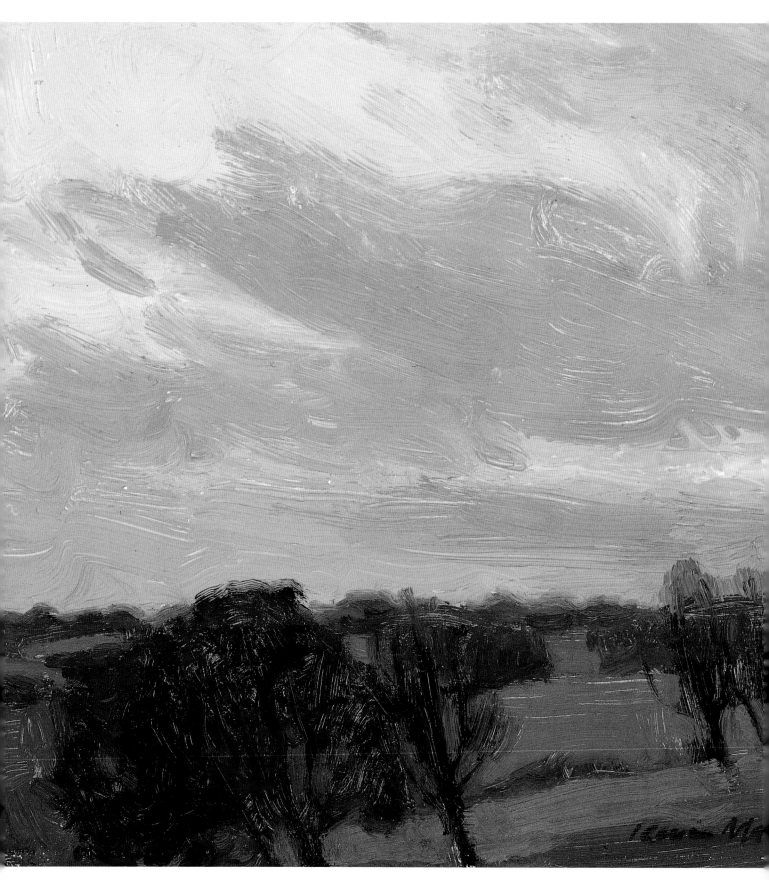

Relate Color Notes
To create the bright, rich color of the sun, start with pure yellow or orange, and relate other colors to this note.

KENTUCKY SUNSET, 6″ × 8″

Introduction

My art reflects an appreciation of nature's colors. They are the inspiration for my painting.

Anyone can learn to paint. My first attempts painting outdoors were horrible. My friends criticized and ridiculed my attempts. They called me the "far-away painter," for they had to be yards away to make sense of my paintings. I did not let their teasing discourage me enough to stop. Had my ego gotten in the way, or if I had not set goals and paced myself, this book would not be a reality.

Through years of producing my own work and teaching, I have developed a simple approach to painting. I take the mystery out of it and make it easy to understand. This book teaches you to see beautiful color. It teaches you to see as an artist. It teaches you a procedure. And it helps build your confidence. You will learn the power of a limited palette, understand light and shade, and construct your paintings simply and strongly from the start. You will learn to master your equipment. The step-by-step demonstrations help you understand how to approach any subject. Learn to paint boldly and assuredly through projects and examples. Those who wish to paint with rich, clean colors and learn to see nature in a whole new light will find this book very valuable.

My goal is to teach you the language of color through figure exercises, and observation skills through still lifes. These basics strengthen your paintings. You will then express this knowledge outdoors, *en plein air*, and back in the studio. With your new color sense, emphasis on the basics of picture making, and practice, you will learn to capture the mood and essence of a scene quickly and accurately.

Many students have visions of becoming professional artists. Others pursue painting for pleasure. Whatever your goal, if I can teach you to see color and put it down with confidence, your road to finished gallery paintings or enjoyment at the easel will be smoother, with better results.

ART AND LIFE
Painting is a culmination of our life experiences. All the things, people and places you have known contribute to it. Become aware of, and sensitive to, the things around you.

The Well-Equipped Painter

Over time, I've developed workable painting stations for indoor and outdoor use. You may develop ideas and setups that work better for you. Painting with friends offers opportunities to share ideas about paraphernalia.

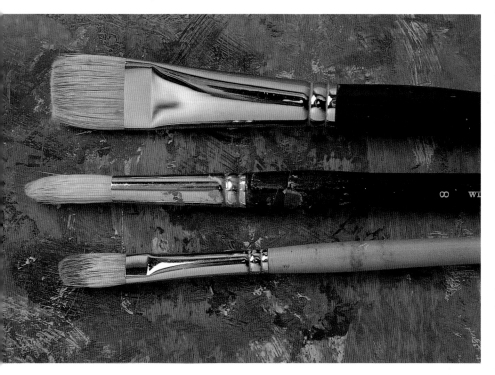

CLOTHING
Wear weather-appropriate, neutral-colored clothing when working outdoors. Bright color reflects into your canvas, influencing colors in the painting. A white shirt reflects too much glare, making it difficult to see and compare colors.

SUN AND HEAT PROTECTION
An outdoor painting session may seem to fly by, while you may actually be standing in the sun for hours. Wear a hat and sun block. Bring plenty of drinking water.

BUG SPRAY
Be prepared. I sometimes spray the ground I'm standing on to protect from nasty fire ants, mosquitoes, yellow jackets, gnats and flies that wreak havoc on concentration.

CLOTH BUCKET
A cloth bucket, available from garden and hardware stores, carries supplies and acts as a trash can for soiled tissues. It has many pockets for paint tubes, trash bags, pocketknife, glasses, turpentine cups, brushes, bug spray, etc. I usually insert a plastic grocery bag inside for trash. When finished, I tie the plastic bag up and toss it away later, leaving the scene as I found it.

SKETCH PADS
Keep a sketch pad handy for small sketches and written notes.

BLACK MARKER
A thick, chisel-pointed black marker can be used to quickly sketch the big shapes and the light-and-shade patterns. The marker keeps the sketch as simple and informative as possible in preparation for painting. If you use a pencil, you may draw "things" instead of shapes.

VIEWFINDER
A viewfinder is a small frame used to isolate a desired scene for painting or sketching. The landscape outdoors can be overwhelming. Looking through a viewfinder helps to isolate and simplify the scene in front of you. An empty 35mm plastic slide mount works great, or cut a rectangular opening, proportional to your canvas size, into a small piece of cardboard. Frame out areas, holding the viewfinder closer or farther away from your eyes to find a comfortable composition of shapes, values and color combinations.

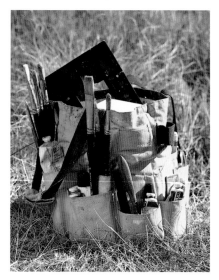

FRENCH EASEL

This piece of equipment is a sketch box that quickly converts to an easel. It accommodates various size canvases, brushes, paints and other supplies, and is sturdy in the wind. Your French easel can also serve you very well indoors.

Pay the extra money and buy the best available. I've seen many students come to class with a brand new French easel that just fell apart by the end of the week. The French easel also comes in a half-size box convenient for travel and backpacking.

To set up your French easel, it is best to turn it upside down on the ground, raising all the legs first, then turn it over. The legs adjust to various heights for uneven ground. A palette is included.

POCHADE BOX

A *pochade* box is a small paintbox with a built-in palette and canvas holder. Some (also called thumb boxes) have a small hole in the bottom so they can be held like a palette. A lightweight, collapsible tripod works great as a support for a small box. A quick-release mount makes it faster and more convenient for setup.

UMBRELLA

An umbrella helps keep the sun off your canvas, palette, and you when painting outdoors. It is better to paint in open shade rather than having your canvas and palette in direct sun. There are some inexpensive umbrellas with pliable C-clamps for attachment to an easel, and umbrellas with long, collapsible, spiked poles for insertion into the ground. Colored umbrellas should be painted with gray spray paint, because bright colors cast a colored glow on your painting and palette, influencing your color mixtures.

PALETTES

Palettes come in many shapes, sizes, colors and materials. I recommend a large surface with plenty of room to mix clean colors. I find disposable paper palettes a little too absorbent. Hand-held palettes are good because they allow you to move back and forth while mixing. Some people prefer a white surface to judge their colors. I prefer a wooden palette made out of mahogany. After each use, I scrape the colors off with a palette knife and wipe with a turpentine-soaked tissue, leaving a tiny film of paint to dry to a glass-like, neutral color surface.

I have an enclosed wooden folding palette. It has a large surface and increases my work space. It fits on my French easel comfortably. The sides open out for space to lay brushes, tissues and turpentine. After each session, the palette just folds up, and the paint stays fresh.

PAINTS

Find the brand and colors that suit your needs. A color of the same name in one brand may be different in another. I use Winsor & Newton oil colors:

- **Titanium White** is very opaque; a good, strong tinting strength.
- **Cadmium Yellow Pale** is a bright, light, powerful yellow.
- **Alizarin Crimson** is a transparent, slightly cool, dark red.
- **Ultramarine Blue** is a brilliant, transparent, slightly warm, dark blue.
- **Winsor Green** is a very powerful, transparent green—a good complement to Alizarin Crimson.

I sometimes use alkyd Titanium White, because it speeds up the drying time of all the colors mixed with it. This is good for travel, when you would like to speed up the drying time.

BRUSHES

Versatile bristle brushes in sizes 4 to 12 do the best job for painting *alla prima* (paint applied in one session). They can be handled delicately, or like a shovel. I recommend using the largest brush possible for the job at hand. Types recommended:

- **Rounds** are versatile, and can be manipulated for many effects, from thick to thin strokes.
- **Filberts** are slightly rounded, flat brushes with a good all-around shape.
- **Brights** are short and flat; great for chiseled strokes.
- **Riggers** are good for signing; they have very long hair to hold a good amount of paint while still giving a fine line.

PALETTE KNIVES

Palette knives and painting knives serve several functions: mixing paint, cleaning off your palette surface, scraping off areas of a painting that need correction, and adding interesting textures to a piece.

CLEANING BRUSHES

While working, I wipe my brushes off with tissue after every stroke, pulling out most of the paint, then I clean them thoroughly with turpentine or mineral spirits and wipe again to pull out the excess turpentine. At the end of the day, I clean them with warm water and soap. After cleaning, I rub a thin layer of soap on the bristles with my fingers, and let it dry to reshape the brush.

TISSUES

Since I clean my brushes off after every stroke, I find tissues more efficient to use than paper towels, because it is quicker to pull out a fresh tissue compared to unrolling towels. Time and rhythm are very important, especially in *plein air* painting.

BABY WIPES

Baby wipes clean paint from your hands, face and clothes.

WET CANVAS CARRIERS

Wet canvas carriers are a must for the traveling *plein air* painter. I have several boxes made with slots to protect stretched canvas or panels while paint is wet. Some carry four wet panels, and some carry up to twenty-four. They can be made to dimensions for carrying various sizes. A 16″×24″ carrier can accommodate any smaller size with a 16″ side, such as 12″×16″, 16″×20″ or 16″×16″.

CANVAS

I use oil-primed linen canvas. I stretch works larger than 16″×20″, and mount smaller-sized canvases on board (Masonite, Gatorfoam or birchwood).

GESSOED BOARDS

I sometimes gesso untempered Masonite or birchwood panels with two to three coats, sanding the final coat lightly. A light coat on the back of the panel helps prevent the board from warping. Gessoed surfaces may absorb the shine out of your oil paints more than an oil-primed linen.

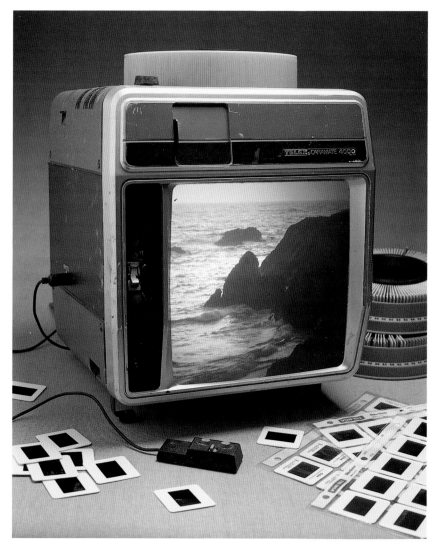

VARNISH

To protect paintings from pollution, like dust and smoke, and keep them looking fresh over the years, it is a good idea to give them a final coat of varnish that can be removed for recleaning. I use Damar varnish, which I apply with a brush or spray from a can. It is recommended that you wait six months to a year before putting on your final varnish, but I rarely keep a painting in my studio for a year. I put a protective layer of retouch varnish on a painting after it is fully dry to the touch. Varnishes come in gloss or matte finish. Gloss adds sparkle and freshness to a surface, as though the paint is still wet. For certain paintings, matte may look better; you may not want that reflective shine.

CAMERA

A camera captures the details of a scene, fleeting effects and numerous composition choices. I use an auto-focus (auto everything) camera. It focuses quickly on moving animals, and captures people on the street inconspicuously. I have a 75–300mm lens that gives me options without changing lenses, and a 55mm lens that shoots closest to our natural vision without distortion. Wide-angle lenses are great for getting the entire scene but create a lot of distortion. I usually carry a camera and plenty of film on my painting trips to give me additional information for studio work. I prefer to use slide film.

SLIDE PROJECTOR

I use a projector that has the capability to project on a TV-like screen, and on the wall. This type of projector doesn't need a big space for viewing, and can be viewed with clarity in a fully lit studio. I set the projector in front of me and respond as if on location. I can knock the image out of focus in the beginning, to simplify big shapes.

MIRROR

Looking at the reversed image of your painting in a mirror gives a fresh, unbiased view of it, and may make it easier to spot problems, such as with composition.

COMMIT TO GROWTH

You need to develop at your own pace. Do not let yourself be discouraged by your spouse or friends, especially while doing the simplified exercises in this book. Pledge to paint one hundred simple, flat, poster-like paintings, as expressed in this book. You will grow and develop. Be patient.

Mounting Canvas on Board

Canvas panels are rigid, lightweight, and a less bulky alternative for painting excursions. I prefer to make my own, because I can choose the size and quality of canvas. The commercially prepared canvas boards available at art stores are made with inferior materials. Commercial canvas boards are fine for practice exercises, but the quality is not good for serious professional work.

Making canvas panels is a good project for times when the weather outside is not conducive to painting, or when you are mentally tired. Then, you need not stop to prepare a panel when your creative juices are flowing. It is time-consuming, so prepare several boards at a time, in stages: cutting boards, cutting canvas and gluing.

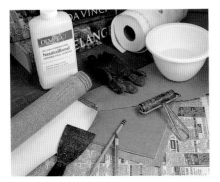

1. SET OUT SUPPLIES

Set out your supplies beforehand at a comfortable work station. Supplies for preparing canvas panels:

Glue
Preprimed canvas
Board (birchwood, Gatorfoam or Masonite)
3″ trowel
Craft knife
Newspaper
Cover sheet
Glove
Books to weight glued canvas
Baby wipes
Paper towels
Water to keep trowel clean
Pencil
Brayer roller

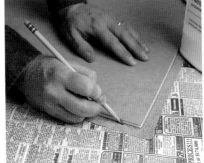

2. PREPARE BOARD AND CANVAS

Cut your boards to desired size. Here I am using Gatorfoam. It is a rigid foam-cored panel. It is very lightweight, strong and warp-resistant. It's lighter than Masonite, which makes it wonderful for travel. Prepare Masonite or birchwood in the same manner.

Lay your board over the canvas, and cut around it with a craft knife, leaving ½″ extra all around. The canvas tends to curl from being rolled, so stack the canvas and board against the curl for a few days, making it less likely to curl up when gluing.

Outline the board with pencil on the linen side of the canvas, to guide your gluing area. Layer sheets of newspaper on your work surface, so you can peel away a sheet as it gets soiled with glue.

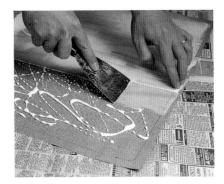

3. APPLY GLUE

For conservation reasons, I recommend a pH-balanced, bookbinding or white hide glue that can be removed easily. I use DemCo Neutral Bond Vinyl Adhesive bookbinding glue. Try other glues available, such as gesso, matte medium, Yes paste, Miracle Muck or Elmer's Glue. Make sure there is no debris on the canvas or board before gluing. You don't want to cause a blemish on your finished surface.

With the primed side of the canvas facing down, pour enough drips of glue over the raw canvas to spread thoroughly. Use a 3″ trowel to spread and squeeze glue into the canvas texture, working horizontally and vertically, spreading a thin, even layer over the whole surface. Pay special attention to the edges, where the canvas is most likely to curl. Remove excess glue.

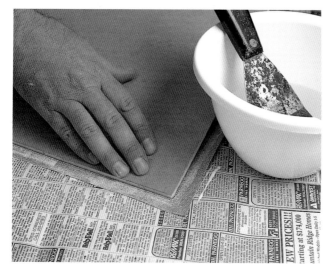

4. POSITION BOARD

Position your board onto the glued canvas and flip it over. Being careful not to get glue on the primed surface, peel away soiled newspaper. Wipe the edges of the canvas with baby wipes while the glue is still wet.

5. EVEN THE SURFACE

Cover the canvas with a sheet of paper to protect the surface from your roller. Don't use newspaper, because the ink will transfer to your canvas. Wearing a glove so you won't get blisters, and using a lot of pressure, work a brayer roller over the surface to get it even and flat, rolling from the center to work out any air bubbles. Push around the edges repeatedly to make sure they are secure.

6. TRIM AND FINISH

The canvas shrinks a little as the hide glue or bookbinding glue dries. If you leave a lot of excess canvas around the edges, it dries at different rates and causes buckling, so trim the canvas off with a craft blade right after it is rolled down, angling it to cut slightly (⅛″) larger than the board. As the canvas dries, it shrinks to the size of the board. Some glues (such as Yes paste) do not shrink.

Stack like-sized canvas boards on top of each other, and lay a heavy book or flat board on top to add pressure while they dry. Add more weight on top of this. Let them dry overnight.

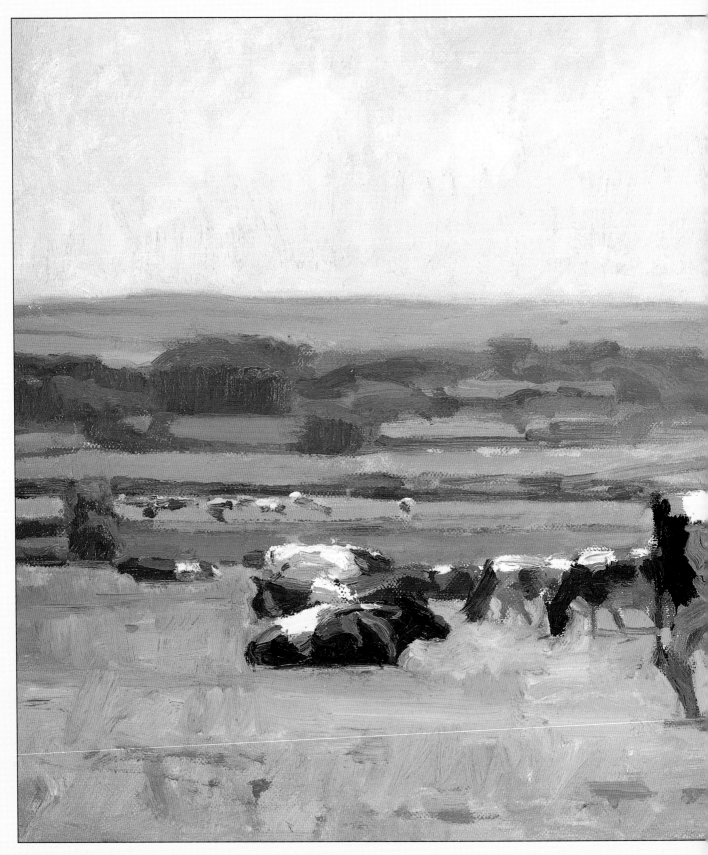

SERENE PASTURES, 12" × 16"

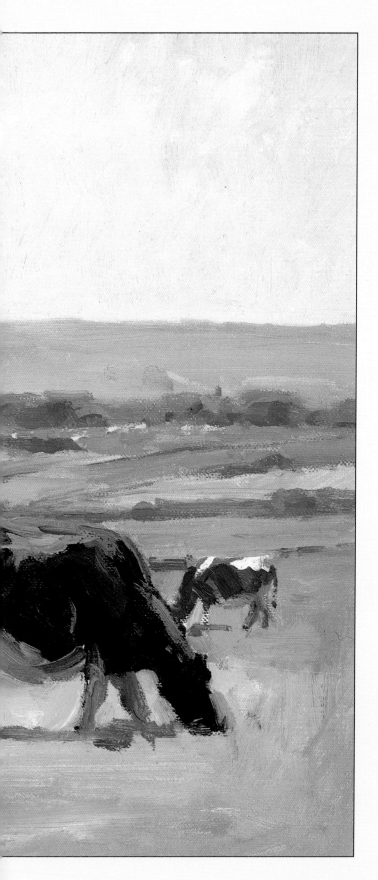

SEEING COLOR ACCURATELY

O nce you have the ability to see color and analyze everything in terms of it, you have total power to paint any- thing you desire. You must train your eye to see and simplify. Painting, especially outdoors, is not an easy task. You must use everything at your disposal to make it go smoothly.

Color Notes, Not Value

What you need to do first is observe nature, to see everything as shapes of color. Proper values (lights and darks) are very important in a painting. However, I try to eliminate the term *value*, because we don't see in values of black and white. Nature displays itself in full spectrum. Color has three qualities: hue, value and chroma. I will use the term *color* or *color note* interchangeably to mean the sum of these qualities. *Analyze everything as a particular color note.*

If you can learn to see color notes, you do not have to worry about value, because that comes automatically. A color note has an inherent value, which makes the process of seeing pure and accurate color easier.

Hue, Value, Chroma
Hue is the name of the color: red, yellow, blue, purple, green or orange. *Value* is the relative degree of grayness (darkness or lightness) from black to white. *Chroma* is the color's intensity or lack of intensity. Compare pure Cadmium Yellow Pale to a less intense Yellow Ochre.

THREE QUESTIONS TO ASK ABOUT A COLOR
1. Where does your color note lie within the spectrum? What is its *hue*?
2. How dark or light is your color note? What is its *value*?
3. How intense or dull is your color note? What is its *chroma*?

Forget What You Know

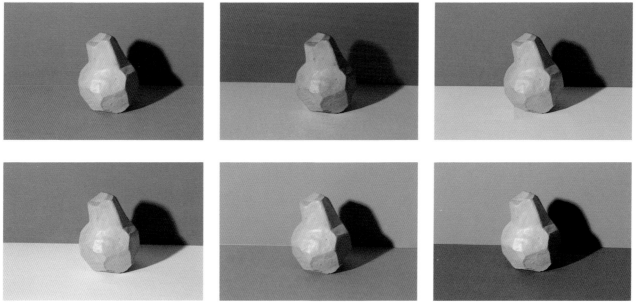

Our preconceived thoughts limit our sensitivity to seeing. We need to eliminate what we *know* about objects and learn to *see* all over again. See as an artist.

Local color is the actual color of a subject, what we would refer to as the red of an apple, the yellow of lemons, or the blue of the sky. Yet as artists we must deal more with the color of light and atmospheric effects on objects. A red roof in the distance may appear purple, even though we know it's red. It is what we know that can get us in trouble.

The sky may appear green, or rose, because of pollution or dust in the air. A yellow lemon may be orange if it is bathed in a red light. That is why memorizing what colors to mix for an apple or sky limits you to mediocre painting. Each atmospheric and lighting situation presents itself differently; each should be painted differently.

Colors Influence Each Other

An object is influenced by the light and color of its surroundings. Examine each one of these photos carefully. A green pear is influenced by the oranges, reds or blues around it. The color of the shadow planes changes with the color of the table top and wall. The interaction of the pear, light and surrounding colors creates a natural harmony. If we cut one pear out and pasted it upon the other background, it would not seem to belong.

FACTORS THAT AFFECT LOCAL COLOR

1. Primary light source (for example, sunshine or artificial light)
2. Indirect light (reflected light bouncing off of other objects, or a secondary light source).
3. Atmosphere (light is filtered through atmosphere, such as particles of dust, water or smog)

Natural Harmony

When we paint outdoors, we usually try to capture a particular type and time of day. If you set up on location and change too much of what you see when you paint the scene, there is no reason to have been on location. If it is a gray day, don't say "I hate gray days," and add a bright blue sky to a grayed-down landscape. It will not be harmonious. All the colors from the sky reflect into the landscape, so we can't change the sky at random, because the color of the sky influences all the colors on the earth.

Sky always harmonizes landscape because the color of the light source (sunlight) through the atmosphere engulfs the scene with harmonious colors. Nature harmonizes everything, so if you paint what is there, the color will be harmonious.

Nature is the best teacher. Painting from life should be the number one goal to set for yourself, whether it be from still-life setups, figure studies, looking out your window or working outdoors.

The Colors of Black and White
When black and white are influenced by direct light, reflected light and atmosphere, they can become many different colors.

SERENE PASTURES, DETAIL

PRACTICE SEEING
Practice engaging in a mental dialogue to sharpen your powers of observation. For example, while riding a ski lift, I constantly look at the movement of the trees, the color of their bark, the reflected light on their trunks. Do branches seem to disappear as they cross the bright sun? What color are the shadows on the snow? Compare things in preparation for painting while doing other things. If you were set up to do a painting right here, right now, you would need to ask yourself many things prior to and during the painting process. Where are the lightest, darkest, brightest, softest or hardest edges? How can shapes be simplified? Practicing this kind of mental exercise will help you learn to see as an artist.

If the color is right, the value will be right.
—Charles Hawthorne

A Colorful World out of Focus

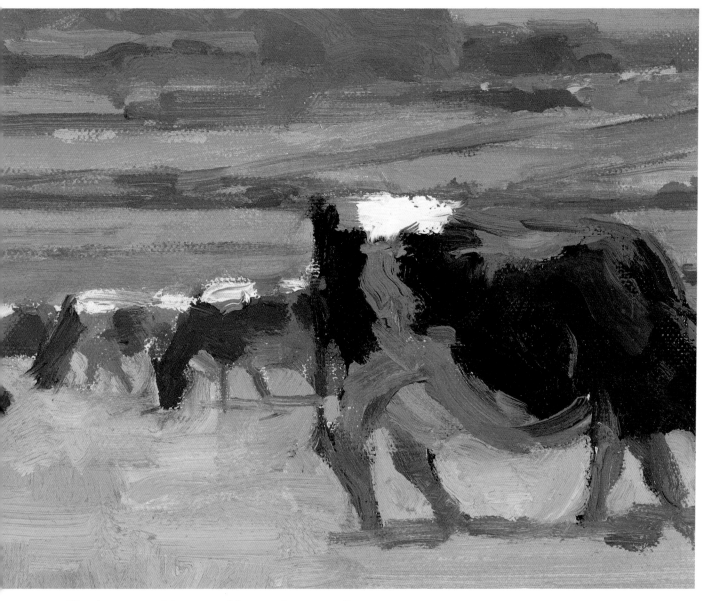

Viewing your subject out of focus increases your color sensitivity, because it makes you concentrate on color only. In this case, near-sighted people have an advantage, because all they have to do is take their glasses off to see things slightly out of focus, which makes the important big color notes obvious. If you are unfortunate enough to have perfect vision, you can learn to adjust your eyes to go out of focus by gently crossing your eyes. It takes a little practice, but here's how to start: Hold your finger about eight to twelve inches in front of your eyes, and focus on it. Remove your finger, but keep your focus where it was. You will see that things in the distance are out of focus. Do whatever it takes to see color notes and not things!

Painterly Planes

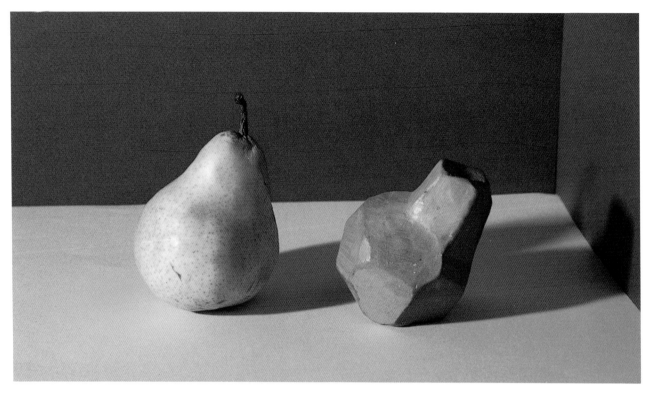

Planes are two-dimensional flat or level surfaces, like one surface of a cube (which has six obvious planes). While a ball has a spherical shape, it can be imagined as having planes. I carved the plane fruit shown throughout this book to illustrate the planes on various rounded objects.

Visualizing planes will help you see, simplify and understand color. Anytime there is a plane change, there may be a color change, and when there is a color change on an object, look for a plane change. In the beginning, it takes some practice to become aware of planes. To paint looser, or more painterly, see and paint the big, obvious plane changes.

Planes

The color transitions in the real pear are more gradual, more gentle, than those of the plane pear, which are more abrupt. But you can see the similarity. Recognizing the planes of an object and noticing at what angles they face light sources will help you see their colors.

LESSON

With modeling clay, sculpt a curved object, such as a pear, using exaggerated flat planes, like the plane pear shown here. If you start with big planes, then make them smaller and smaller, you will eventually have the illusion of a rounded form.

Color Is Relative

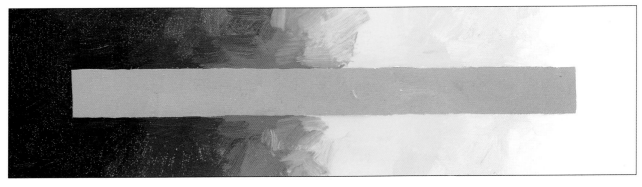

How We Perceive Colors

Because the eye perceives a color in relationship to those around it, a color surrounded by dark colors is perceived as lighter than the same color surrounded by white. Experiment by surrounding a color with different colored grounds; its appearance changes with its surroundings.

One color can become darker, brighter, grayer, warmer or cooler in relation to another color. You must relate and compare all the colors in your composition to each other. Compare similar colors in order to spot subtle differences between darks, lights, reds, blues, etc. Look for the warmest, coolest, brightest, dullest, darkest and lightest variation of each color.

One aid to judging colors accurately is to hold up something dark (like the side piece of my eyeglasses) over a dark shadow area. A thin brush or stick will do. This helps me see how dark, and what color dark, that shape is. Also, when painting outdoors, I often put a white tissue on a bush, so that I have a pure white object to compare colors with.

Compare every color note you see with another, and ask yourself two questions. *Is one color lighter or darker than the other? Is one color warmer or cooler than the other?* Your eye will become more sensitive to delicate color relationships as you practice comparing colors and increase your powers of observation.

THE MAGICAL COLOR ISOLATOR

The best way to see true color is with a simple device I call a *color isolator*. A simple version can be made out of a 1″×3″ piece of white cardboard with a hole punched through it.

Holding the color isolator about six inches from your eyes, close one eye and position the hole so that you can see the color of the subject area you are judging. This isolates a small piece of color so that you no longer see a thing but only a specific color note.

When looking through the color isolator, do it fast. Trust your first quick impression. Even if the side of a face appears bright green, believe it. Flesh can be any color in the rainbow depending on its surroundings and light source. The color isolator will help you visualize without preconceptions.

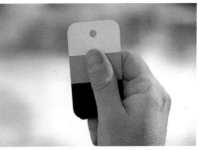

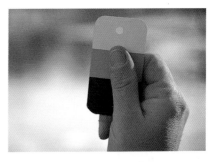

My Color Isolator

On one side, my color isolator has black, white and neutral gray sections. Each section has a hole, so that I can compare how a color note looks surrounded by black, gray or white. The opposite side is all white, so that I can compare up to three areas at once. Notice how obvious the color notes are with the background out of focus.

Gallery of Fresh Color

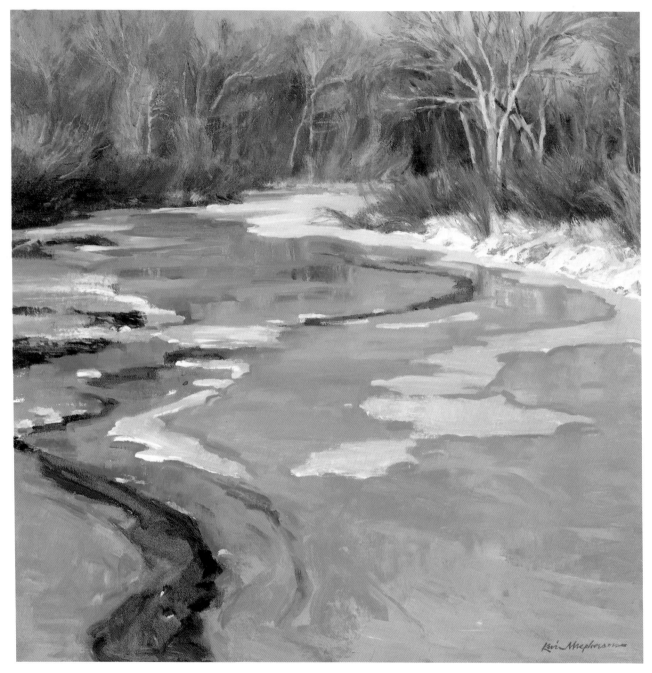

Paint What You See
When you paint color notes, and not actually things themselves, you automatically end up with a more realistic and beautiful painting. As I painted this icy river, I saw cool blues, greens, warm grays, etc. When I stepped back, I realized that I had created the reflection of the trees and sky. Paint what you see, not what you know.

RIO AZUL, 24" × 24"

See it, mix it, put it down. Be decisive.

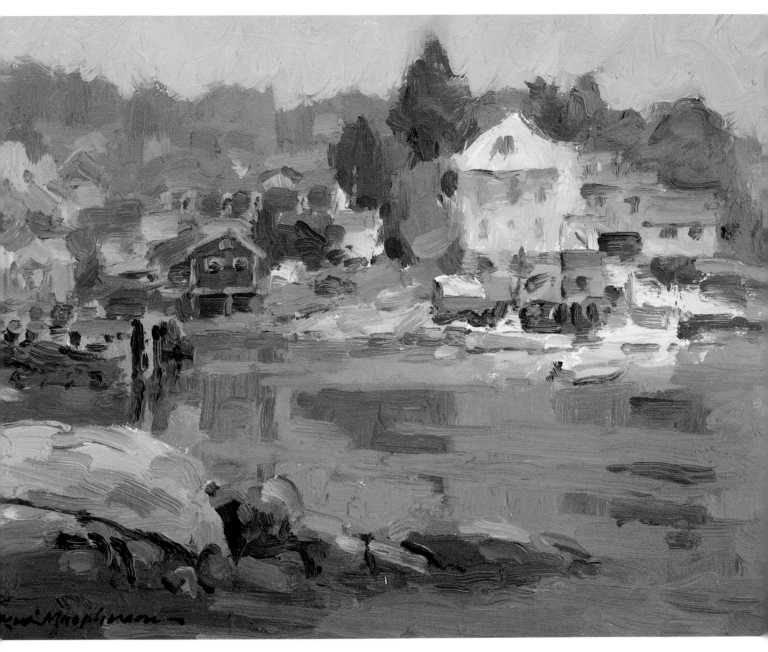

Intensify Your Color Sense
Looking at the world with a softer focus actually intensifies your sensitivity to color. I painted this piece without my glasses (almost blind). I saw colors and put them down, and when I was finished those colors had created houses, boats and water.

STONINGTON HARBOR, 6" × 8"

COLOR NOTES
Putting the right color note in the right place will create a realistic image.

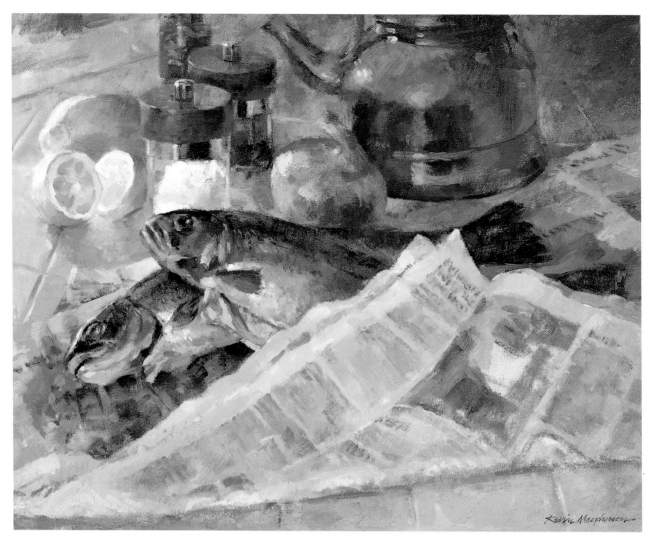

It's Not the Details

Details do not necessarily make for a better painting. Accurate color notes ring true more than slavish rendering of details. I have had people come up close to this painting to read the type on the newspaper, only to be amazed that it's just strokes of color.

FRESH CATCH, 16" × 20"

PLANES AND COLORS

Any time there is a plane change, there may be a color change, and when there is a color change, look for a plane change.

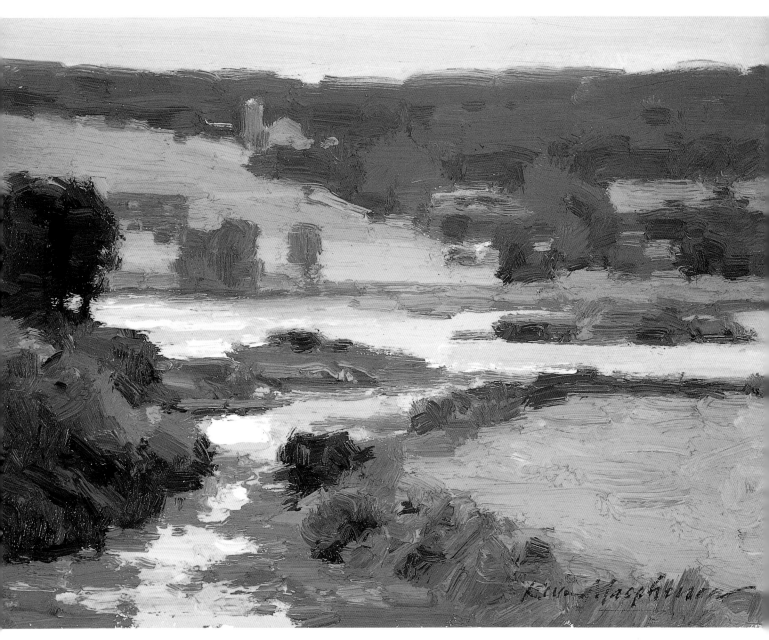

Natural Harmony

Be alert and trust your eye. No two skies are alike, and trees are not always green. One of the major influences on local color is the color of the main light source, which bathes objects with a unifying color. The grayish yellow of the sky here influences the color of the entire landscape.

CANADIAN REPOSE, 6″×8″

COLOR AND VALUE

Every color has an inherent value.

EVENING AT BLENNERVILLE, 30" × 40"

MIXING CLEAN, FRESH COLOR

Artists' pigments can't compete with the range of colors in nature, but learning to mix color with a simple, limited palette teaches you important color relationships that unify your painting. When you mix the right colors and lay them next to each other, you give life and truth to your painting.

Macpherson's Palette Layout

I arrange my palette with Cadmium Yellow Pale, Alizarin Crimson, Ultramarine Blue and Winsor Green along the left and top edges. A good amount of Titanium White (more than the other colors) is squeezed along the bottom.

Squeeze out paints in long "worms" to keep the color clean as you use it. In the beginning, when you're learning, it might be wise to use a less expensive paint, so you get into the habit of having an ample amount on your palette. Have enough paint to mix and cover the canvas so that you don't waste time and lose momentum squeezing out more during the painting process. Organize your palette the same way every time, so that you become familiar with its arrangement. You want to be able to act impulsively and intuitively. To keep up with the fleeting effects of nature, you should know exactly where each color is, so that you can reach for it without breach of thought. If you know where the colors are, your painting rhythm will not be interrupted.

To keep my colors clean and fresh, I clean my palette by scraping it with a palette knife many times during painting. Save these gray paint scrapings on the side of the palette. They are useful for other later mixtures.

Don't be stingy with your paint.

Achieving Harmonious Color With a Limited Palette

I have many students who paint with twenty or more tube colors on their palettes. Such beautiful arrays can quickly turn to mud in the hands of the inexperienced.

The primary colors for pigments are red, yellow and blue. Since all the other colors, an amazing variety, can be made by mixing them, why not use just these three and white? The process of mixing is easier and less confusing if you do. A good painting has both variety and unity. Working with a limited palette puts you at a greater advantage to create color harmony, or unity.

The primaries red, yellow and blue are separate colors as far as can be. They are *not* harmonious, because they are irreducible; they have no elements in common. However, as soon as we mix one into another, the resulting color is somewhere between the two. There is a dialogue between them, making them distant cousins. Use only three colors to mix all your various color mixtures; greens, oranges, purples, reds, grays, etc. You will then see very easily how they are all related.

My choices for a limited palette are Titanium White, Cadmium Yellow Pale, Alizarin Crimson and Ultramarine Blue, because they in-clude the primaries, as well as a range of values from light to dark. The primaries can be mixed to obtain the secondary colors (orange, green and violet); tertiary colors (yellow-orange, red-orange, red-violet, blue-violet, blue-green and yellow-green); and endless grays.

Practice with only Titanium White, Cadmium Yellow Pale, Alizarin Crimson and Ultramarine Blue before adding Winsor Green. This is a very strong color that can be used for more than just mixing greens. It makes rich blacks when mixed with Alizarin Crimson. Add more colors to your palette, if you like, one at a time.

WARM AND COOL COLOR TEMPERATURES

As you learn to mix color, become more aware of color temperature; *warm and cool color relationships.* For obvious reasons, fire and sun colors (yellows, oranges and reds) are considered to be warm; the colors we associate with ice and water (mainly blues) are cool. Greens and violets have qualities of both. A color's temperature is also relative to other colors. One yellow may be cooler than another, just as some blues are warmer than others. Adding white both lightens and cools.

A

B

C

D

Warm and Cool Relationships
Color note A is warm compared to B, but A is cool compared to C, and B is warm compared to D.

Mix and Match

Pure tube colors are rarely found in nature, so you must create mixtures. A few tubes of paint can yield endless variations.

Start a mixture with the most obvious color choice on your palette; yellow, red, blue, green or white. If a color is very light, start with white. You can also begin with a previously mixed puddle to get the next color.

Conduct a mental dialogue with yourself to determine color mixing choices, asking questions as you work. Let's say the color note on your subject is closest to yellow, so begin with that. What needs to be added next? Perhaps a small portion of red, which makes the mixture yellow-orange. But it is still too light and bright. Add a small amount of blue, orange's complement—the color directly opposite it on the color wheel. This makes the puddle darker, slightly cooler and less intense.

A color note on your subject may be warm blue, not too intense, and of medium value. *Is it lighter or darker than the mixture on your palette?* Add some white if the subject appears lighter. Does your puddle of color need to be a little more yellow, red or blue? In other words, *does the puddle need to be warmer (towards yellow or red), or cooler (towards blue)?* If the subject appears less violet than your puddle, you may want to add violet's complement, yellow.

Once you feel confident that the color note on your subject and the color puddle on your palette match visually, put a small test patch in the appropriate area on the canvas. Hold a color isolator (see page 23) about six inches from your eyes, and quickly compare the isolated spot of color to the isolated spot on the subject. Adjust your mixture as necessary.

Mixing Color Charts
Mask off squares with tape on a canvas board. Create various mixtures with colors. Fill the squares with the variety of mixtures. Use thick paint. Clean your brush and palette after each mixture. Reduce each mixture with white five times, or spend an hour just mixing out of a puddle on your palette. Move the puddle from pure to gray, light to dark, red to blue. See the delicate to drastic changes you can make.

WHAT COLOR IS THAT?

Many students ask, "What colors did you mix to get that?" I usually don't know, because there are hundreds of ways to combine colors.

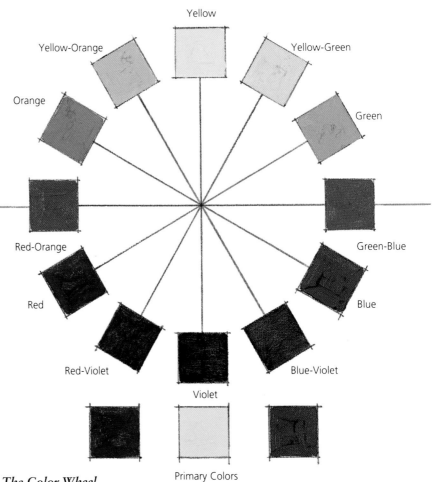

The Color Wheel
The primary, secondary and tertiary colors make up this color wheel. They all come from the three primary colors. Each secondary is mixed by combining two primaries. The tertiaries also contain our original three primary colors.

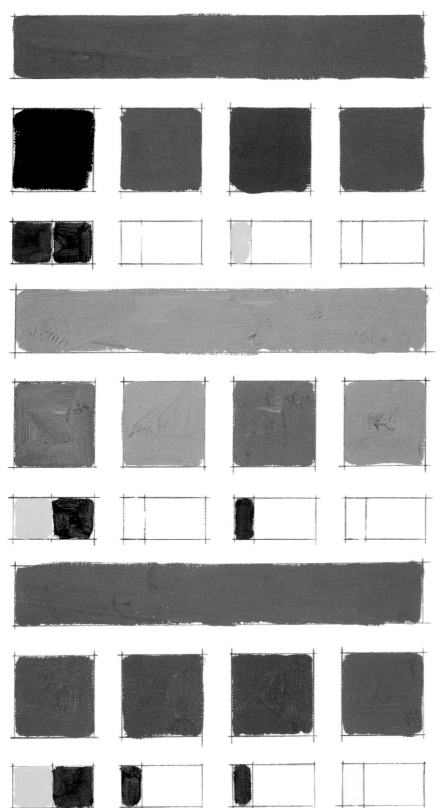

Mix and Match

These three examples started with a color note to match. I then began my mental dialogue, and made obvious mixtures (left) for rough approximations of the desired colors. Were my initial mixtures too dark, or too light? Were they too warm, or too cool?

Top: The color note to be matched is a medium-value, medium-intensity purple. My initial mixture of Alizarin Crimson and Ultramarine Blue created a dark purple. I added white to lighten, which resulted in a too-intense purple. I added yellow to dull the note, but it was still too dark. I finally added more white for a match.

Middle: The color note to be matched is a dull green. My initial mixture of Cadmium Yellow Pale and Ultramarine Blue produced a too-dark, too-intense green. I added white to lighten, which resulted in the correct value, but it was still too intense. I added Alizarin Crimson, the complement of green, to gray it, which made the note too dark. I finally added white again for a match.

Bottom: The color note to be matched is a rich dark orange. My initial mixture of Cadmium Yellow Pale and Alizarin Crimson created a rich red-orange that was too warm. I added Ultramarine Blue to cool and gray down the note, but then it was too cool. I added red to warm it up, but it was still too dark. I finally added white for a match.

COMPLEMENTARY PAIRS

Complementary pairs include yellow and violet, red and green, and blue and orange. Adding just a small amount of a complement will tone down a too-intense color without changing its value (lightness or darkness) too much, but it will change the value some.

What About Earth Colors?

Earth colors are pigments like Yellow Ochre, Burnt Sienna, Burnt Umber and Raw Umber made from minerals such as iron, manganese, copper, etc. I do not use them, because they are too convenient; many artists reach for them because they appear to be close enough to the color desired. Once you familiarize yourself with your limited palette, you will soon see that you can mix close to all the earth colors with it. It is better to mix browns accurately with a limited palette. A brown is a warm, dark orange. When looking at a brown, ask if it is more red, yellow, or towards blue; mix pigments accordingly.

BROWNS

Browns can be beautiful color notes, but many beginners use them too much. They can turn a painting to mud if used indiscriminately.

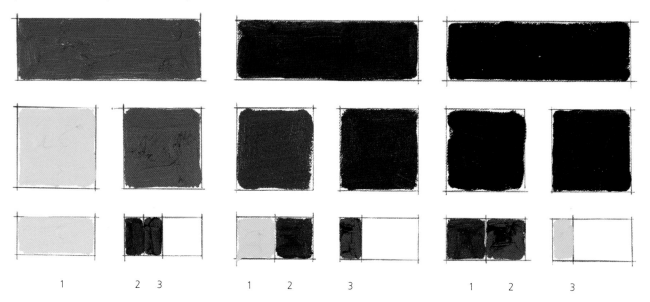

1 2 3 1 2 3 1 2 3

Mixing Earth Colors
The top color strips are the following earth colors directly from the tube: Yellow Ochre, Burnt Sienna and Burnt Umber. You can achieve very similar colors with the approximate proportions of the primaries indicated.

Mixing Sensitive Grays

If you can't exactly name a color, it is often what is called a *neutral gray*. Neutral grays include warm grays, cool grays, browns, mauves (not just battleship gray), etc. Grays are perhaps the most important unifying colors the artist has, because they bind together the bright, intense color notes in a painting, and are useful for adding variety and interest within major shapes.

There are infinite possibilities for producing beautiful, subtle grays when mixing colors. They include all the potential combinations of the three primaries (with white) in varying proportions. One way of mixing a neutral gray is to start with a color and add an equal amount of its complement.

Determine what kind of gray you are looking at. Does it favor yellow, red or blue? Practice and become adept at producing subtle grays of the same value, with warm and cool variations.

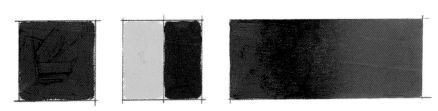

Mixing Neutrals With Complementary Colors
The complement of one primary color is achieved by combining the two remaining primary colors. Yellow is complemented by violet—a mixture of red and blue. Red is complemented by green—a mixture of yellow and blue. Blue is complemented by orange—a mixture of yellow and red. Combining a color and its complement will result in a neutral color, which may favor one complement depending on the proportions of the mixture. Adding white will help you see more clearly if a color is being favored.

BRUSH MIXING
Mixing with your brush takes less time than mixing with a palette knife and switching over to a brush.

Gallery of Color Mixing

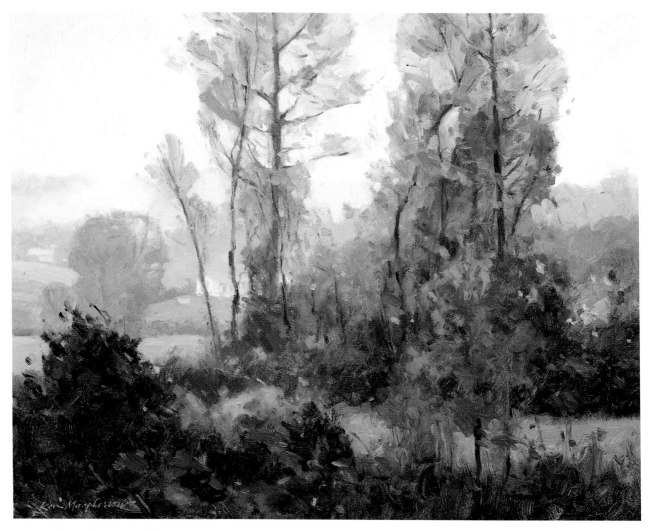

Grays Complement Brights

If everyone is shouting, no one is heard. If all your colors are bright and intense, nothing stands out. This bright-red maple tree stands out against the concentration of grays that complement and support the whole scene.

FLAMING MAPLE, 16″ × 20″

KEEPING COLOR NOTES FRESH
Clean your brushes after each color note.

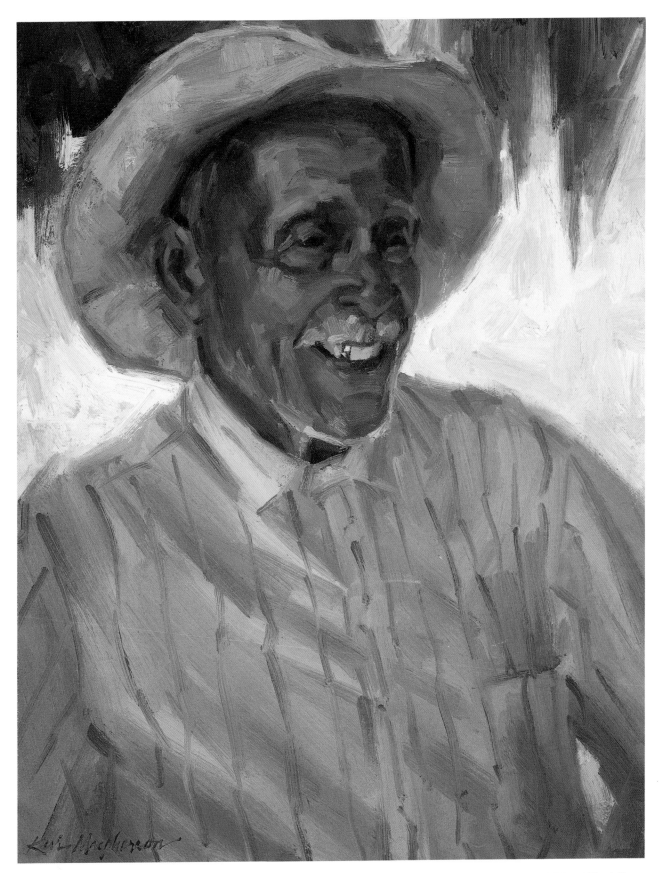

It's All Relative

A woman at an exhibition once asked me, "Did you use real gold for his tooth?"
I couldn't let that go by. "Of course," I said. However, it's just paint. The
painting was done with a palette of only yellow, red, blue and white.

MAN WITH GOLD TOOTH, 18" × 14"

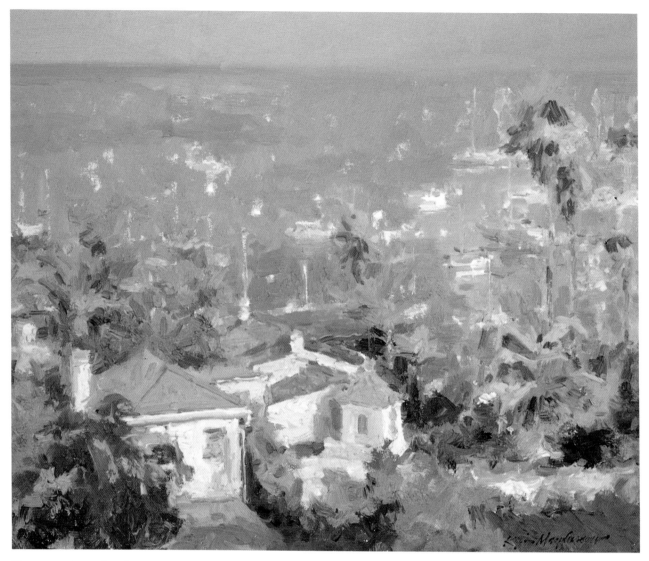

Warm and Cool Colors

The combination of warm and cool colors gives vitality and a feeling of light to this harbor scene. The color notes in the water, from left to right, are darker purple, then blue, then warm purple.

CATALINA SUNSHINE, 16″ × 20″

VALUE OR COLOR TEMPERATURE?
Many times we mistakenly adjust value when perceiving a color change in nature, though perhaps there is really only a slight temperature change. Squint to see if a value contrast actually exists before mixing and laying down your color notes.

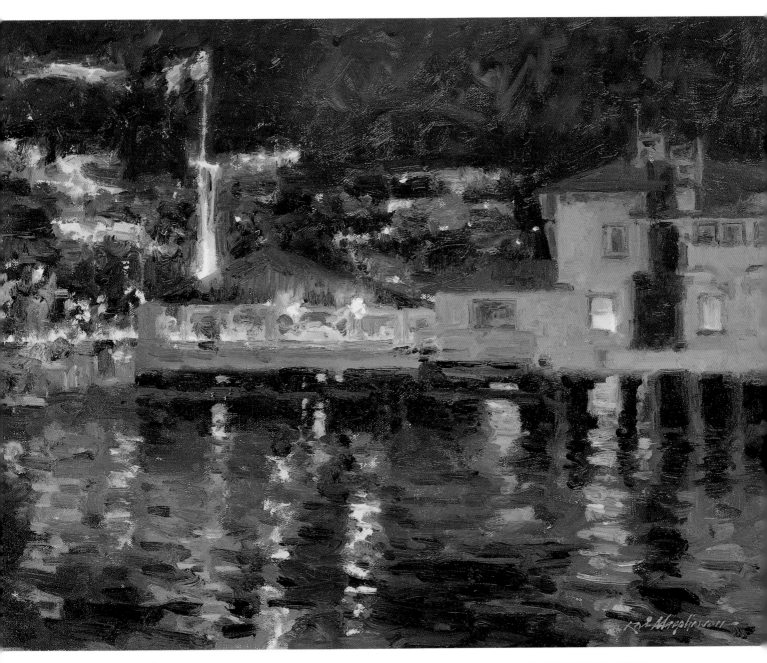

Know Your Palette

You must ask yourself the same questions when painting night scenes as you do when painting day scenes. Everything looks black at first, but once your eyes become acclimated to the darkness, you will see that there is a darkest area, and that other areas appear more colorful. Ask yourself, "What is the lightest light?" It is very important to know your palette when doing nocturnes. Set your colors out the same way every time.

YACHT CLUB—NIGHT SCENE, 16″×20″

FIRST COLOR NOTE

The first color note you put down must be accurate, because all subsequent colors are related to it.

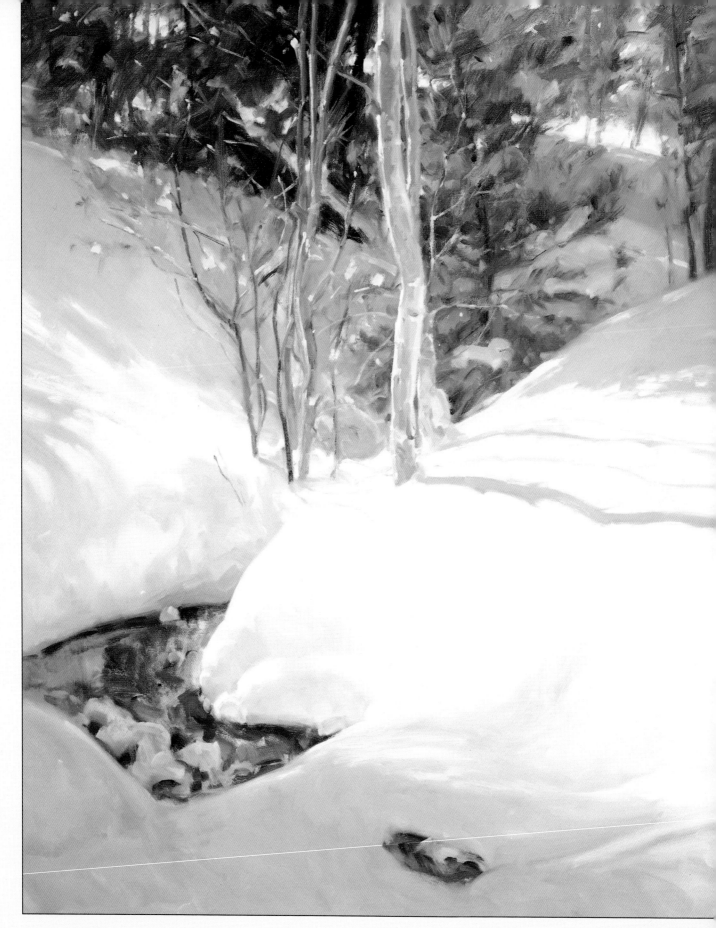

SNOW COVERED STREAM, 30" × 36"

THE LIGHT FAMILY AND THE SHADOW FAMILY

A clear understanding of light and shade will help you create an illusion of reality in your paintings; it also holds your paintings together. Subtle, less obvious conditions are more difficult to analyze, so begin by working with a single, strong light source to better acquaint yourself with the principles of light.

All parts of the subject that are more directly illuminated by the main light source are members of the *light family*, while the *shadow family* is made up of areas not directly lit by the main light source. Both can be influenced by indirect light, such as reflected light bouncing into shadows. Separate the pattern of light and shade at all costs. It is better to push the extremes.

Many students paint a white object too light because they don't clearly understand light and shade. A white vase becomes a part of the shadow family if it is totally immersed in shade; a dark object's local color may be very dark, yet parts of it may belong to the light family if it has light shining directly on it. Light conditions can defy what we think we know; a white shirt in shadow may be a slightly darker color note than a black shirt in sunlight. Do not let any light values cross over to the shadow values.

Light and Shade

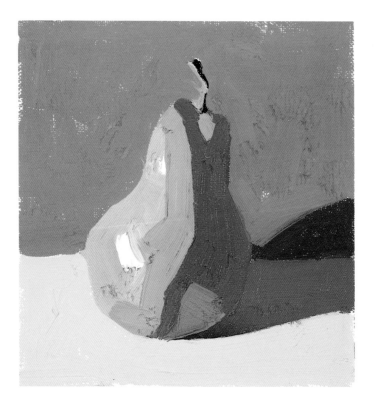

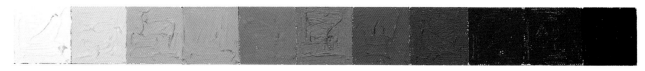

Full Color
The light and shadow families are rendered in full color notes, with the components of each family simply stated.

CLARIFYING THE FAMILIES—
A STUDY IN BLACK AND WHITE

Forget about color for the time being. If you squint your eyes way down as you look at your subject, it is easier to see the light and shadow pattern. There is a link between all the lights and a link between all the shadows.

To reinforce this pattern, it is helpful to analyze your subject in black and white. Use a thick, pointed black marker to indicate all areas in the shadow family in solid black. Leave the white paper for areas in the light family.

Do not confuse darks with shadows. Dark objects receive light and shadow too. If a white object is in shade, fill it in solid black. If a black object is in light, leave it white.

Do your study on paper. This separates the process of clarifying light and shade from the process of seeing color. Approach your canvas first and see the shadows of the color notes.

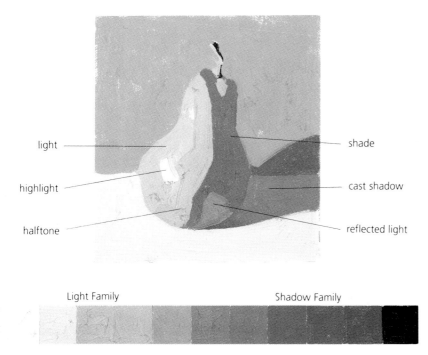

light ——————————— shade

highlight ——————————— cast shadow

halftone ——————————— reflected light

Light Family Shadow Family

Black and White Values
Colors have an inherent value, as represented in this black-and-white version of the full-color reproduction shown here. If you determine the correct color note, you will automatically obtain the correct value.

THE LIGHT FAMILY AND THE SHADOW FAMILY

The *light family* includes surfaces more directly illuminated by the main light source. It includes highlights, or planes angled towards the light source, and halftones, planes angled slightly away from the light source. The *shadow family* includes planes not directly illuminated by the main light source. It includes planes angled away from the light source, areas where no light falls, and cast shadows where the light is blocked by an object casting a shadow on another surface. Reflected light can be bounced back into a shadow, filling the shadow planes with more light and color than if the reflected light were not there. Squint to see it disappear.

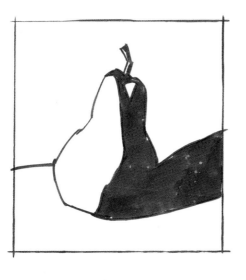

Sketch
A study in black and white clearly separates the families, distinguishing the most obvious contrast.

Simplifying Your Families

If there are many separate lights or shadows describing a form, link them somehow to create more simplified shapes, while still maintaining your overall light-and-shadow pattern. For example, the snow pattern in illustration A is slightly more scattered than in illustration B, which has been simplified. Connecting and creating larger shapes makes for a more organized, flowing pattern. The rivers of light and shadow in illustration B make for a stronger, simpler painting.

A

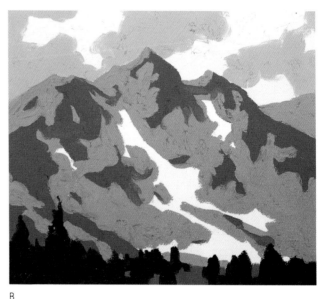

B

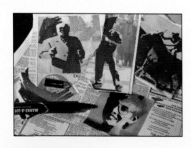

MARKER ON NEWSPAPER

Reinforce the concept of the pattern of light and shadow by doing exercises on newspaper pictures or actual photos. Analyze the photos, then fill in the shadow shapes in solid black.

Consistent Yet Varied Patterns
This painting has a very obvious pattern of light and shade; yet each shape in both
the light family and the shadow family is filled with color and variation.

CALIFORNIA CANYON, 16″ × 20″

SQUINT!
Get in the habit of softening
your focus and squinting:
Soften your focus to see color,
squint to see contrast. But
don't paint as dark as you see
when squinting.

Adding Variety to Your Families

Color changes occur within both the light family and the shadow family. You want to fill the shapes in each family with glowing color. While shadows have less light, they are greatly influenced by the power of reflected light to fill them with glowing color. Such indirect light adds variety and form to the shadow family. Highlights and halftones add interest and form to the light family. You will destroy the families if the value changes within them are too abrupt. Look for color temperature changes (warm and cool) first, instead of value changes. Destroying your light-and-shadow pattern will create a "muddy" painting.

LIGHT REFLECTS AT ANGLES

If you understand how light reacts when it hits an object, it will help you determine the color note of a specific plane. Direct light reflects off the surface of an object at a right angle, 90 degrees. The more directly the light hits the surface, the lighter it will be. As the angle becomes more oblique, the plane will be less and less influenced by the light source, whether it is a main source or reflected light. If you know the angle at which two planes face each other, think about how the reflected light from an opposite plane will hit the plane of the object you are painting.

SHADOWS FIRST

Establish your shadow pattern first, even though they will change rapidly outdoors. Painting the shadow shapes first is very important to assure clean bright color and a consistent pattern of light.

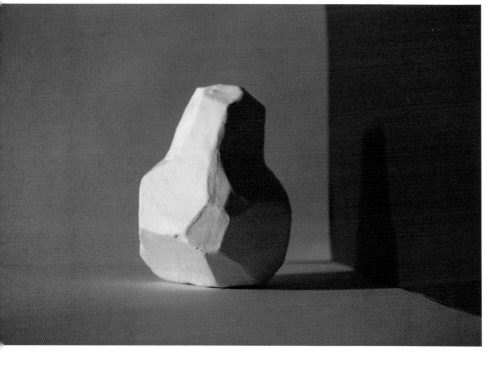

Reflected Light

A strong main light source establishes the light and shadow families. In the light family, many of the planes on the far left surface of this object are in direct light, while the halftone plane facing down towards the floor picks up reflected yellow light as it turns away from the main light source. In the shadow family, planes facing the red wall receive red reflected light. Even the cast shadow on the yellow floor is influenced by the red wall, turning that shape orange. The shadow planes facing the yellow floor directly appear to be the most yellow, while those influenced by both the yellow floor and the red wall appear more orange as they turn towards the wall. Yet reflected light is not strong enough to destroy the shadow and light families. The influence of various light sources on planes is more easily seen on white objects, but it is necessary to see them on colored objects as well.

Look for the lightest light and the darkest dark.

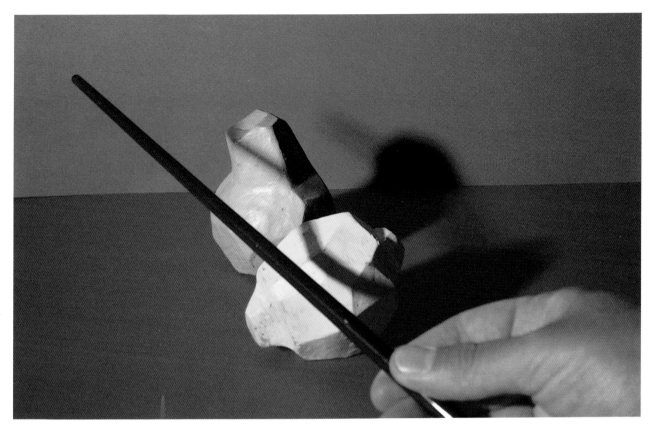

You Can't Cast a Shadow on a Shadow
If you cast an additional shadow across your forms, you will find that it casts only on the light family, and fades into the shadow family.

LIGHT AND SHADE Q & A

Analyze your subject:

1. Where is the light source? Knowing at what angle light hits planes helps you determine how they are receiving light.
2. What color is the main light source? This influences your whole light family.
3. Where is the darkest dark in the shadow family?
4. Where is the lightest shade in the shadow family? This is usually darker than the darkest color note in the light family.
5. Where is the darkest color note in the light family? This is usually lighter than the lightest shade in the shadow family.
6. Where is the lightest light in the light family?

Gallery of Light and Shade

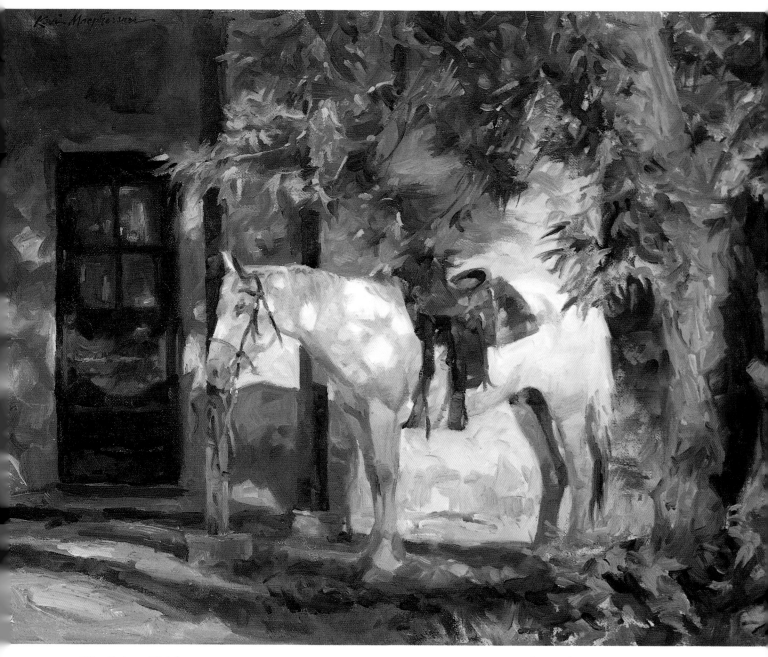

The Color of Light

I'm more concerned with color and the feeling of light in this painting than the particulars of saddlery. The beautiful color notes on the leather, the dappled warm and cool light on the white horse—these are what appeal to me. I used Yellow Ochre, Alizarin Crimson, Ultramarine Blue and white to obtain a full spectrum of harmonious colors.

TEN MINUTE BREAK, 14" × 18"

▶ Plane Changes

I exaggerated the planes in this painting, so that the swans appear as if they are carved out of wood. There are definite plane and color changes. Look at the planes on the neck and back of the swan in front. The planes that face the sun receive more light. The cheek plane facing down and the plane on the back of the neck are lit with reflected light.

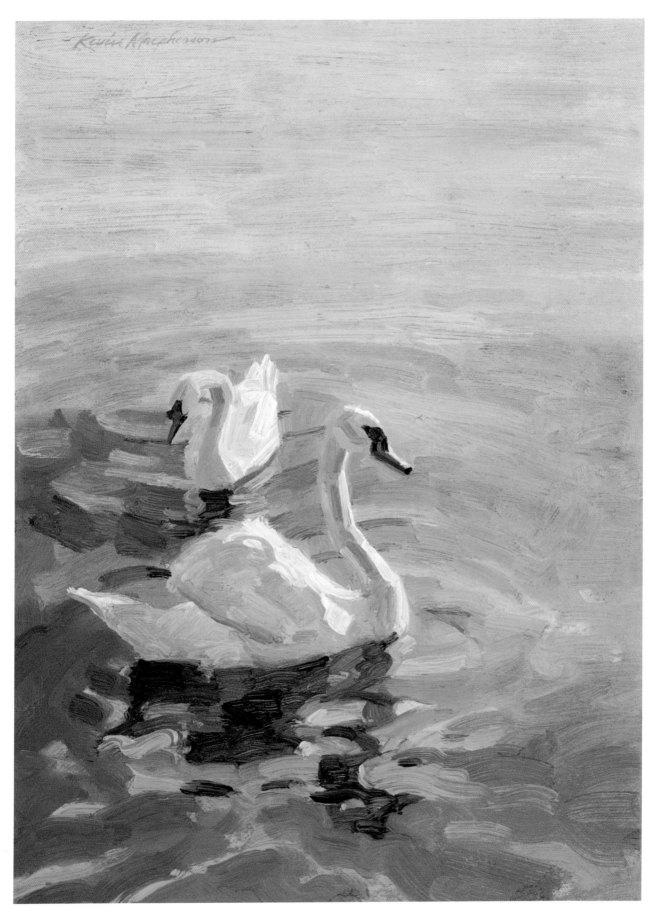

DUET, 12″×9″

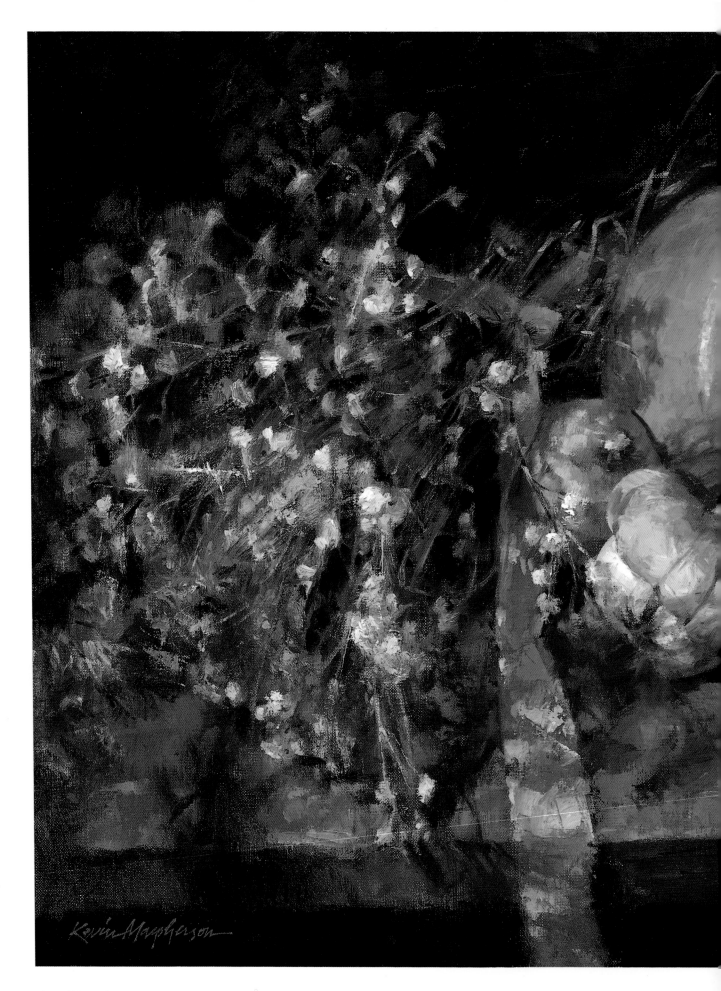

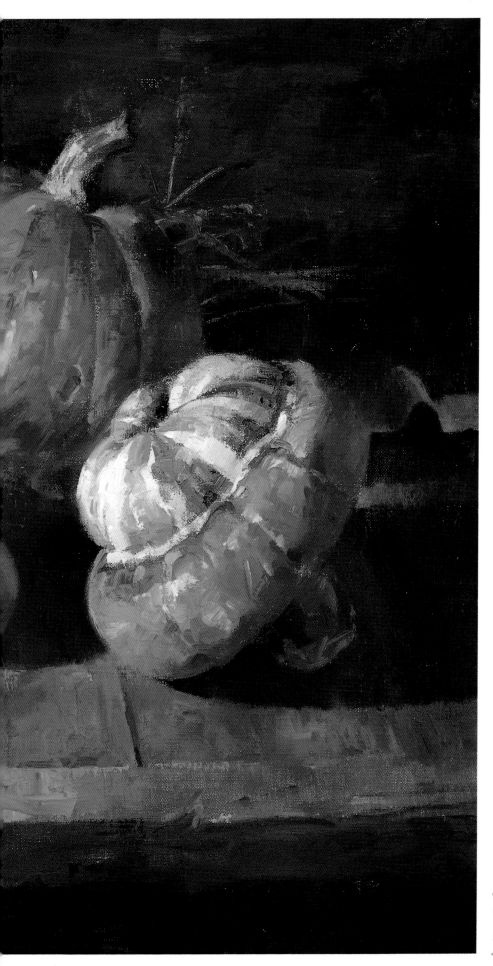

Reflected Light Adds Variety

Reflected light helps model form and give variety to our shadows. For example, look at the rich, bright reflected light in the shadow family on the small squash in the front of this composition. However rich and bright, it remains in the family of shadow.

FALL HARVEST, 18" × 24"

Overlapping forms help create the illusion of space.

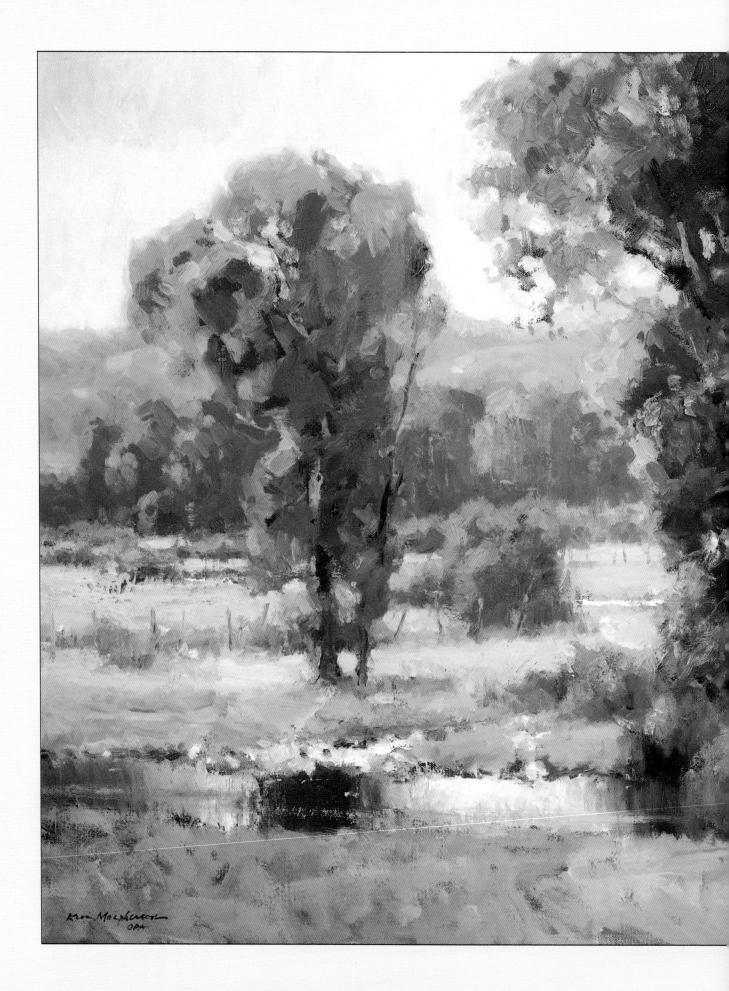

SIMPLIFYING SHAPES FOR A GOOD START

A good painting has unity and variety. Variety adds interest. Design your shapes to add variety. Create each major shape differently. Think of your painting as a mosaic of large and small interlocking shapes. Do not paint things. The correct shapes and color notes in the right places create realistic images.

SUMMERTIME STILLNESS, 24″ × 30″

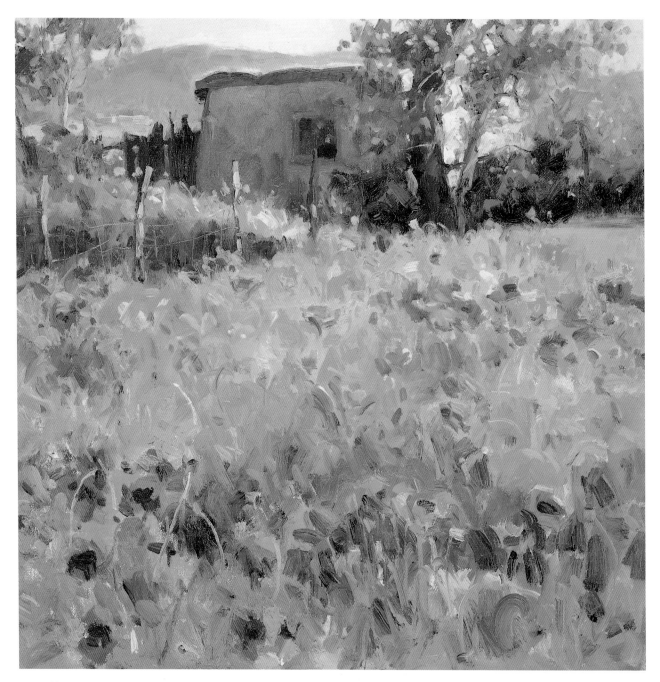

A Brilliant Beginning

Taos, New Mexico, gets a splash of brilliant poppies every June. When painting brilliant, intense colors, it is best to lay them in first and go around the shapes with the surrounding color. You want to keep these brilliant colors as clean and rich as possible. If you put red on top of green, it will immediately gray the red and make it muddy. It is easier to gray a color down than to make it brighter.

DAYS OF SUMMER, 20" × 20"

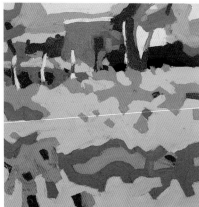

CHOOSE YOUR SHAPES

Nature may suggest shapes, but you must select the best shapes for your painting. Do you want a small mass next to a large shape? Or a delicate, lacy shape next to a large, heavy one?

Making a Strong Start

Reducing elements to the fewest and most basic shapes is very important in painting. Paint the big, obvious shapes and relationships; the little details will take care of themselves. Many students say they have trouble finishing a piece, but most often the problem lies at the start of their painting process. Most people can't finish because their foundations have not been properly laid. Practice striving to get the right shape and color relationships established in the beginning.

Start by painting large, flat color masses with your brush instead of drawing in the linear sense. This helps build your paintings simply and strongly from the start. Then work down towards the details, which are really just small shapes. Do not worry about finishing a piece, because it is how you start that is important, both for the painting and your growth as an artist. Finishing details will then progress easily and naturally.

LEARN TO SIMPLIFY

Since we often identify things by their shapes, correct silhouettes help make objects recognizable. Pay attention to the outer contour edges of the shapes. Are they soft-edged shapes, or crisp hard edges? Think of building your scene with sheets of colored construction paper. Imagine cutting out the shapes very simply. Use as few large shapes as possible to get your canvas covered.

Thinking simply will build your painting quickly. Look at your subject and ask what one color choice best represents that mountain, tree or sky. Imagine you are cutting the shapes out of colored paper; this helps you to think big. If you also imagine you will be charged one hundred dollars for every piece of colored paper you use, you will be very selective. If you only had two colors or values of paper, such as black and white, how could you best represent the scene? See pages 70-71 for more examples of finished paintings re-created with big shapes.

All paintings are lessons for the next. It's an ongoing learning process, increasing skills for future works.

Negative Shapes

Pay special attention to negative shapes. This is the space around a subject that is utilized as part of the design. Working with negative shapes—actually painting what's behind an object—makes it easier to create interesting positive shapes.

Artists are sensitive, receptive, more aware of their surroundings, feelings and impulses.

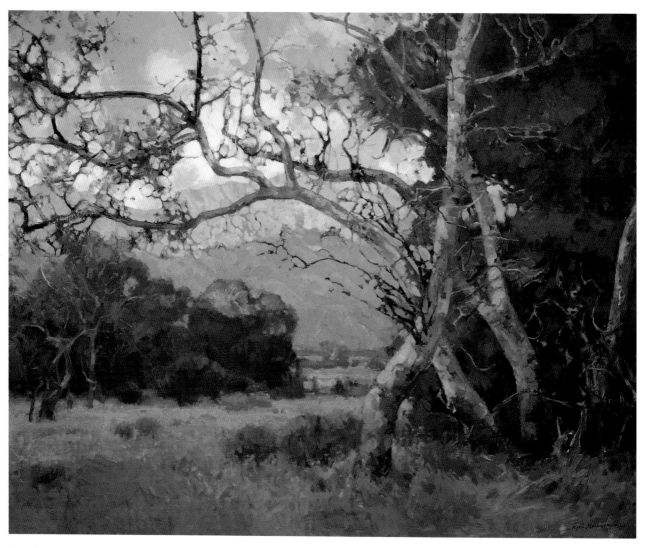

Sensitive Spaces
The rhythm and gesture of these sycamores are captured because of attention to the negative spaces between their boughs.

SUNLIT HILLS AND SYCAMORES,
40" × 50"

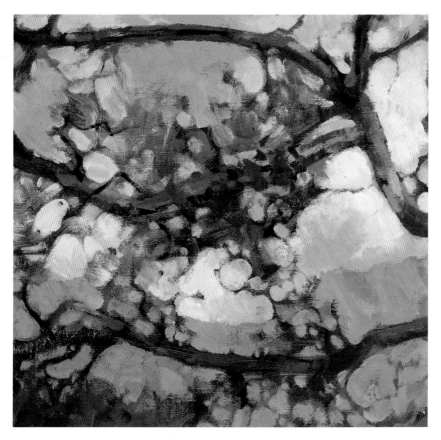

SUNLIT HILLS AND SYCAMORES,
DETAIL

Negative Spaces

Notice the variety of spaces, lines and masses within and around the branches in these details. Look at the color combinations created from groupings of small branches. The sky, cloud, mountain and foliage colors create the shapes of the branches as they are painted around them.

NEGATIVE SHAPES

Use negative shapes to create the shape of a subject.

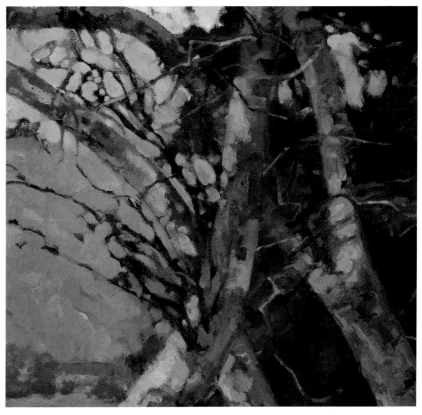

SUNLIT HILLS AND SYCAMORES,
DETAIL

DEMONSTRATION
START WITH ONE SHAPE

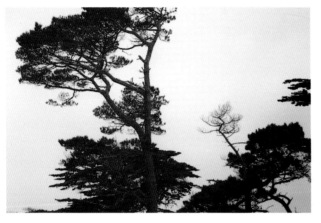

1. PHOTO REFERENCE

YOUR FIRST COLOR NOTE
Take time mixing the first color note you put down, because all of the others will have to relate to it. It's all relative, so get the first color as accurate as possible.

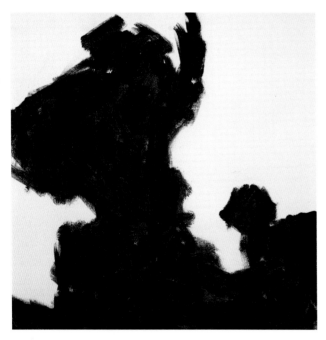

2. PAINT THE MAJOR SHAPE

Mass in the general color and major shape of the tree, applying the paint relatively thinly. Forget about the small branches and small spaces. Paint a simple, abstract shape. Be conscious of the remaining spaces of the white canvas.

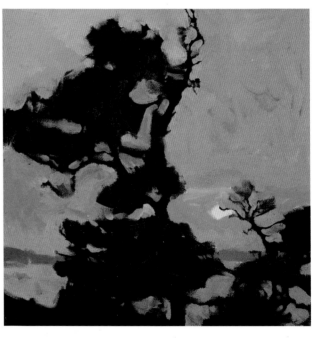

3. PAINT THE SUNSET SHAPES

Use the sunset shapes and colors to further describe the tree, using thicker paint than the base shape. Pay attention to the negative spaces: small, long, angular, curved. Create variety. Be aware of the edges of the shapes: very soft, more crisp. At this stage, apply the paint and leave it alone, so as not to pick up the underlayer.

4. VARY THE SPACES

As you apply your paint at this stage, let some of the underpainting mix with it to soften edges and vary the values of spaces. Some sky holes between the branches are darker than the major mass of the sky; in general, the smaller the space, the darker the color.

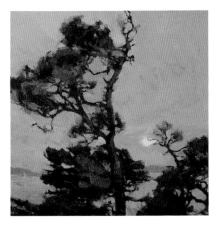

A SERIES OF CORRECTIONS

Painting is a series of corrections; when there are no more to be done, you're finished.

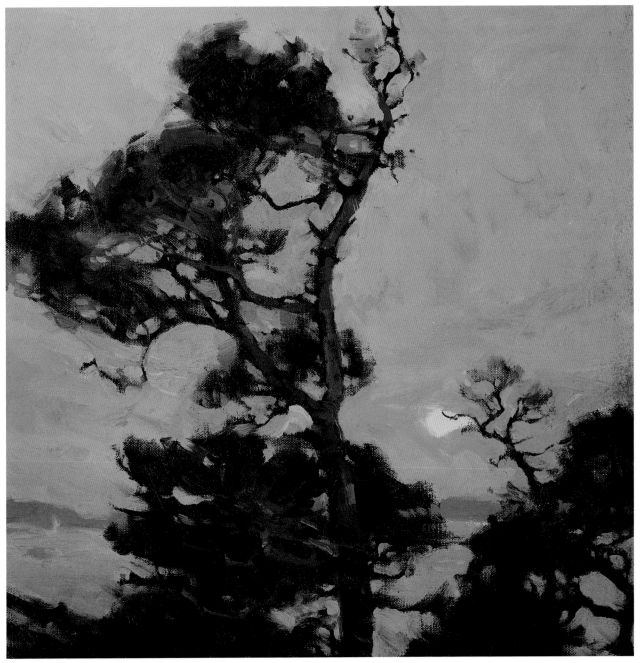

5. RESTATE AND REFINE

Restate and refine areas with bold strokes, and reshape negatively.

PACIFIC SUNSET, 16″ × 16″

General Steps for Constructing a Painting

1. PAINT THE LIGHTEST LIGHT

What color is the lightest light? A white shirt drenched in warm lamplight may be pink, orange or slightly yellow—not pure white, as you might think. Never use pure white, but white with a small amount of color in it. Check with your color isolator for accuracy.

2. PAINT THE DARKEST DARK

What is the darkest dark? What color is it? How dark is it?

3. PAINT THE EASIEST COLOR

Pick the easiest color to put down; that is, the easiest color to get right

without a lot of mixing. If an object is the same color as Cadmium Yellow Pale straight from the tube, that's easy. To check a rich, bright color in nature, hold up a pure color, such as a pure red, on the brush. Compare how much lighter or less brilliant that bright note may actually be.

4. ESTABLISH THE SHADOW PATTERN

After you've laid down your lightest light, darkest dark and easiest color note, establish all the shadow shapes. It is easier to gain control over light family colors by first placing all the shadow shapes accurately. What are the shadow shapes? What color are they? Put them in the right place, and this step is done. Laying in the shadows first guarantees clean color throughout.

5. FILL IN THE LIGHTS

Keep all the color notes in the light family lighter than the shadow shapes. Lay them down flatly and simply. Cover the whole canvas, thinking about shapes. Step back and recheck your color choices. Don't be in a hurry to produce a finished painting.

PUT IT ON AND LEAVE IT ALONE

Mix up thick, opaque color and put it down with simple strokes. The amount of paint on the brush, and proper brush pressure, is vital when applying your paint. Putting thick paint down boldly forces you to make definite decisions. Believe your first impression; if you look too long, your perception may change. Be decisive. A boldly applied stroke looks right because the artist made a decision and stuck with it. Putting down a stroke and then restating it once or twice pushes the paint into the underlayer, making the color muddy. Put it down and leave it alone. If the underpainting is too thick, scrape it off. You can lay paint over a thick area by painting the next layer even thicker.

100 STARTS

Pledge to do one hundred starts—simple, flat shape studies with no detail. They can be figure studies, still lifes or landscapes. Give yourself thirty minutes to cover a canvas with properly related color shapes; this will exercise your speed skills. Strive for more accurate relationships with each one. The more starts you do, the better you'll become at them. Number your starts to chart your progress.

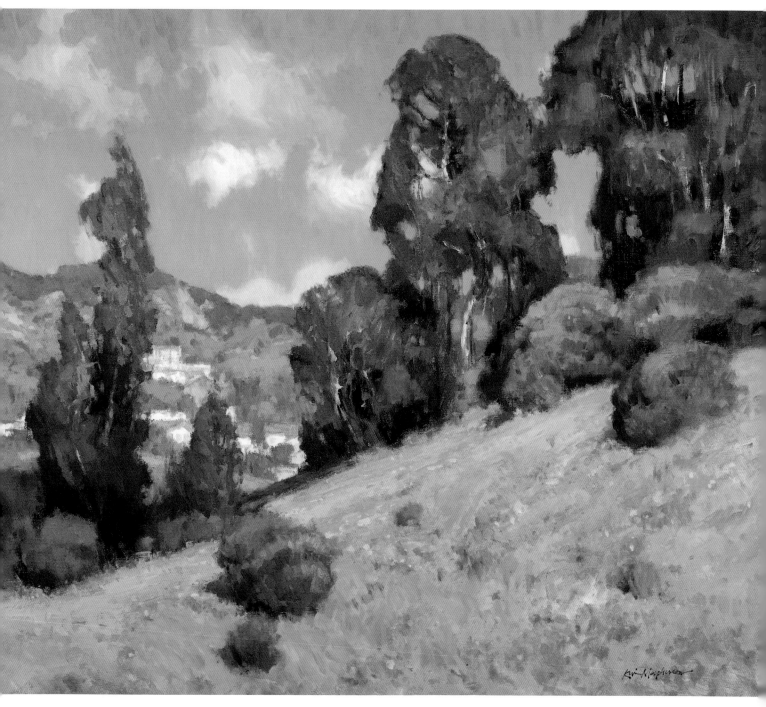

Bold, Flat Shapes

Think shapes, not flowers. This hillside of flowers is not much more than an arrangement of flat, abstract shapes. There are no flowers rendered in detail, even though we know what those shapes are because of the way their edges are handled. The small bits of color off the major masses tell us what size all those flowers are.

LAGUNA HILLSIDE, 30″ × 36″

PAINT SHAPES

Paint shapes of color, not things.

PRACTICING SIMPLICITY WITH FIGURE STUDIES

Figure studies are good practice exercises for seeing various color and value relationships between different combinations of clothes, accessories, backgrounds, hair and skin tones.

The Big Shapes
Do not paint the features. Paint the big shapes. Do not think separate objects. The ear, face and neck are all one interlocking shape.

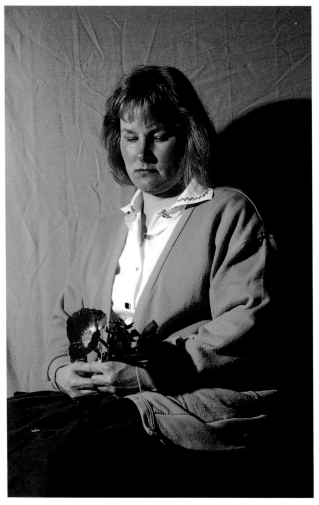

1. THE MODEL

It is best to have your model dress in simple colors. Establish an obvious light-and-shade pattern with a strong light source, such as a spotlight. Don't let overhead lights or windows diffuse your shadow patterns too much. This photograph is a good exposure of the light family, but not the shadow family. Notice how dark and colorless the shadows are. It doesn't show the colors the eye can usually see in shadows. However, it does indicate the overall shadow pattern well.

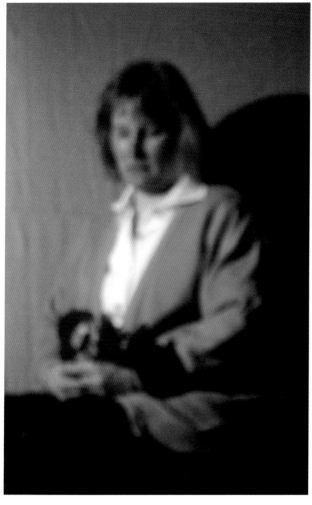

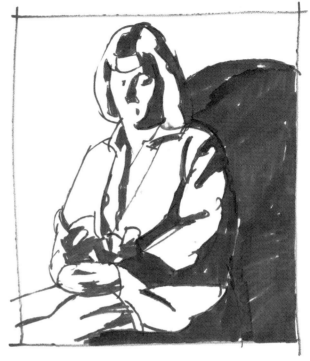

3. BLACK-AND-WHITE SKETCH

Organize your pattern of light and shade with a black-and-white sketch, indicating all the shadow areas in solid black with a marker. This will separate your light family from your shadow family, and show their relationships, which you will retain in the color study. If you make this sketch directly on your painting surface, you can paint right on top of it. However, the black marker will bleed through in time, so I don't recommend this for serious paintings.

2. THE MODEL OUT OF FOCUS

Squint to see the shadow pattern and the largest, most important shapes. This out-of-focus photograph reduces the major shapes to their most obvious color notes.

Squint.

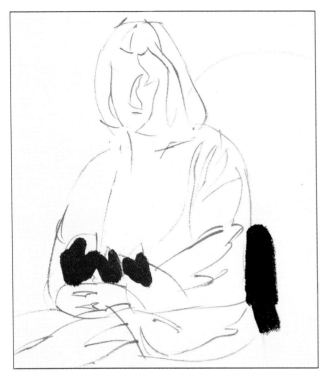

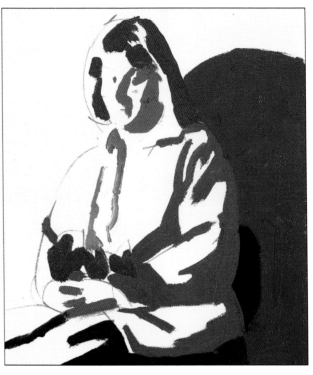

4. ESTABLISH EXTREMES

Work on a white canvas, because it is easier to judge accurate relationships. Establish the lightest light, darkest dark, and easiest color.

5. ESTABLISH MAJOR SHADOWS

Establish the major shadow shapes in living colors. Do not look for details and small shapes too soon.

Start simple.

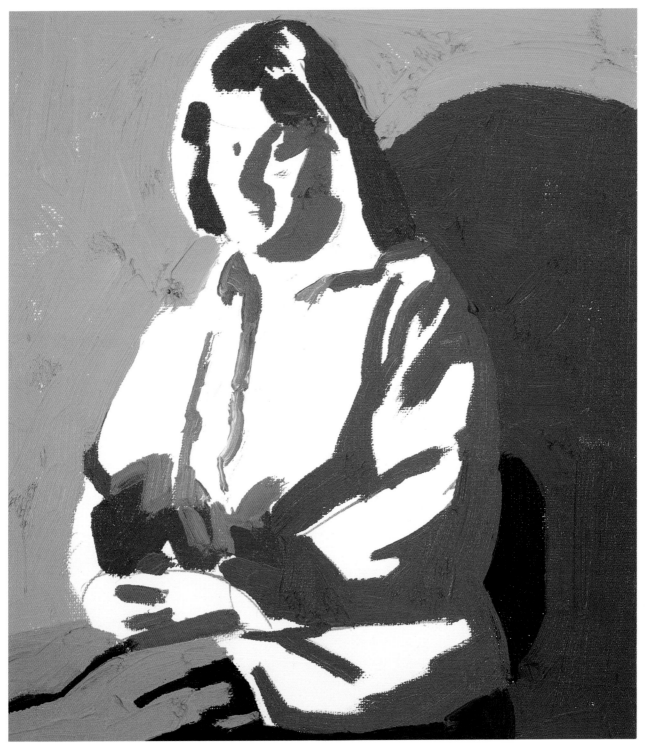

6. THE LIGHT FAMILY: BACKGROUND AND SKIRT

The background color is just as important as the head or shirt, because it has a relationship with the subject. As you begin painting the light family, reshape your shadow shapes negatively (as in the thin shapes on the blue skirt).

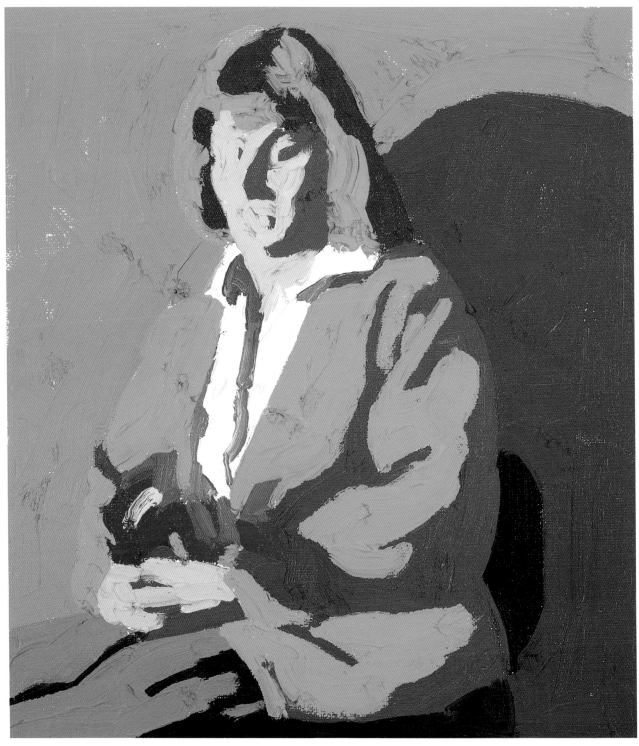

7. A FINISHED START

The figure is just an arrangement of shapes, colors, light and shade accurately placed. This is a good start.

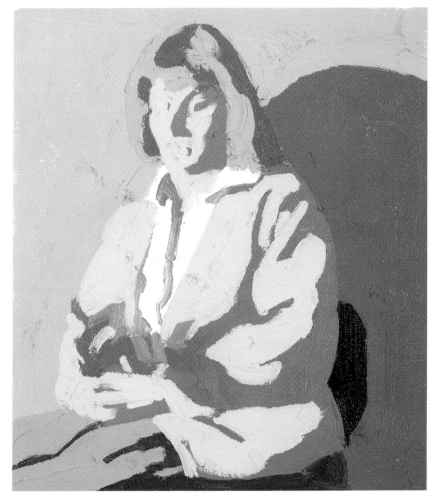

KEYING YOUR PAINTING

The lightest light and the darkest dark set the value range and key of your painting. The key of a painting is like the key of a piece of music; you can play a song in the key of C or the key of E, but it is still the same music, just higher or lower. Painting is similar; you can start your painting warmer, cooler, lighter or darker. It's up to you. When painting in a high key (light), you need to establish your darkest dark much lighter than it appears. In a low-key (dark) painting, the lightest light will be darker. Your value range will probably be narrower in a high- or low-key painting, but the same principles of relationships are applied.

Black and White Values

Notice the values in this black-and-white reproduction of a good start. If the color is correct, the values will be correct, because color has an inherent value.

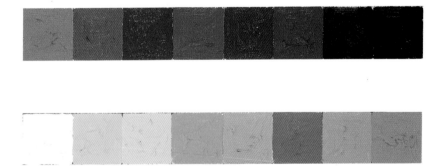

The Color Notes

Sometimes the change from one color note to another is only slightly lighter, darker, warmer or cooler. Notice that all the shadow colors are darker than the light colors. Making correct color choices from the start ensures the rest of the painting will go smoothly. A wrong note will pop out, so change it right away.

Gallery of Shapes

Look for a Variety of Shapes
Look for variety all over the canvas. Each of the five trees in this piece is different: warmer, cooler, redder, twisted, straight. Consider the variety of spaces between the trees. Sometimes a shape will look different but the weight of it will feel the same. Imagine filling these shapes with sand. Do not use the same amount of sand for each shape.

FROM A DISTANCE, 26"×29"

Consider a temperature change instead of a value change.

Different-Sized Shapes

It is not necessary to render and explain everything with equal emphasis. The depiction of a few ducks will carry the impression of the others that are not so explicitly described. Notice the groupings of the duck shapes; two, three or six together create different-sized shapes throughout the piece.

SUNDAY SWIM, 30" × 36"

Add details only if necessary.

JUDGING COLORED SHAPES
Each colored shape you put down flatly and simply helps you judge the next, and all the color notes after it.

Work From the Big Shapes
If you squint, the most obvious shapes and contrasts will present themselves. Each finished painting here has been re-created with big, hard-edged shapes, as if they had been cut out of construction paper. Try to visualize your subjects in as few properly-related shapes as possible. Use thick, bold, juicy strokes to fill in these simple areas. It is amazing how finished your paintings can be with just a little attention to variety within each shape, and to the edges where the major shapes meet. In fact, a simple, flat arrangement of shapes can look quite finished and painterly on its own. Students often have a hard time seeing the validity of these studies, because they look at finished paintings and see all the details. But working from the big shapes to the small is very important. When you truly understand the value of the first painting stages, you will be ready to go further.

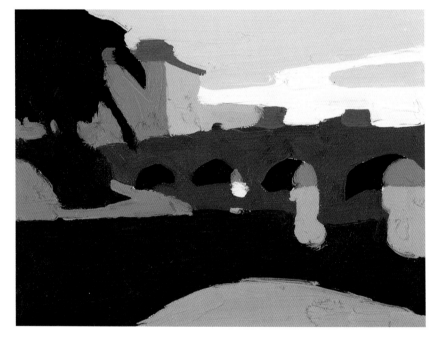

Simplify the Scene

Even though this painting has a light, airy quality with lots of detail in the shadows, I never lost sight of the graphic silhouettes. The window is the brightest shape; the objects and figure inside are silhouetted against it.

SPOT OF TEA AND SUNSHINE, 11″ × 14″

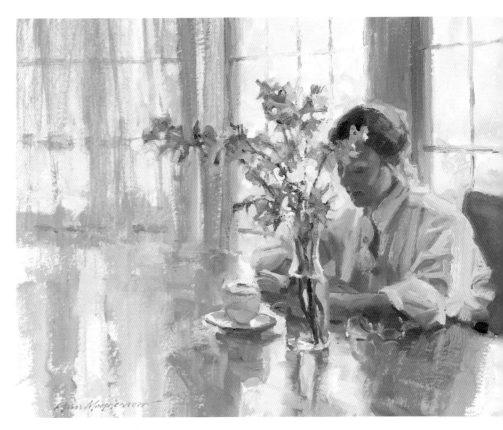

SMALL SHAPES

Details are just small shapes.

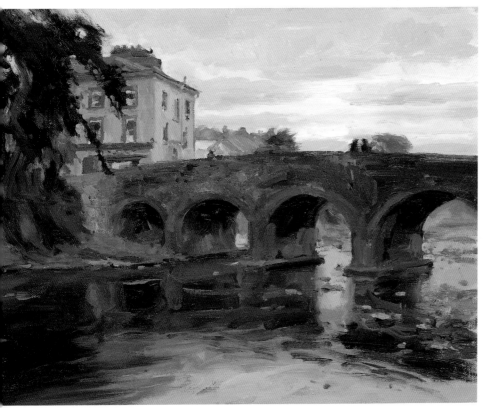

The Big Silhouette

An overcast day will not present an obvious pattern of light and shade. Look for the big silhouette of the land and the sky. This is our first big shape. The light is from the sky: cool with warmer shadows.

KANTURK CROSSING, 12″ × 16″

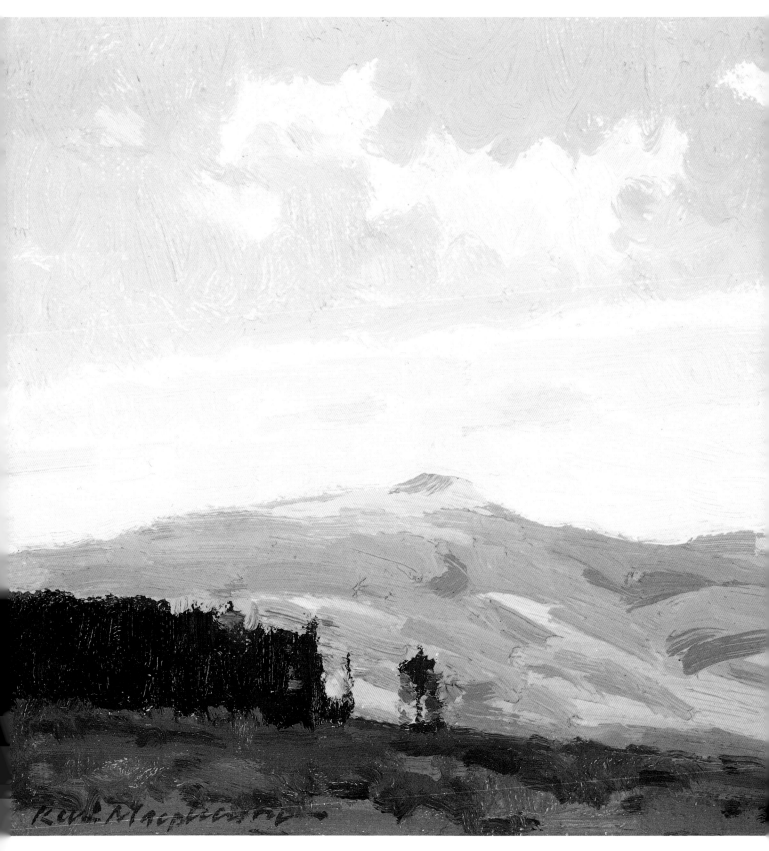

Balanced Shapes

This is a very simple, quiet composition. The large mass of trees on the left is balanced by the single tree on the right. That small tree is important. Without it, the painting doesn't feel right. In a good composition, all the parts are necessary.

GROS VENTRE OVERTURE, 6″ × 8″

The S-Sense of Painting

In the course of my painting and teaching, I've devised a set of one-word guidelines for good painting. It's the S-Sense (and the essence) of Painting:

STARTS
The basic foundations of starting a painting are the basis for growth.

SIMPLE
"Keep it simple" applies to just about every aspect of painting: gear, subject matter, painting process, colors, etc.

SHAPES
Focus on shapes, not things. Think of your paintings as mosaics of interlocking shapes; some larger, some smaller, but all related. Make all shapes interesting, and pay special attention to negative shapes. Start with flat silhouettes of color.

SOFT
In general, try to keep edges soft. Hard edges attract the eye.

SUN
Since the sun is constantly moving, establish a single direction and color for the sunlight in your painting. Keep sun-side (light family) shapes separate from shade (shadow family) shapes.

SHADOW
Place shadow shapes before light shapes for more control, looking at the color of shadows carefully to see how they reflect the sky or nearby objects, and how they contrast in both temperature and value with the light family.

SIX COLORS
Simplify your palette by using six or fewer colors. This approach lets you mix any color relationships you want, and gives your paintings color unity.

CREATE REALISTIC IMAGES
Correct shapes and color notes—accurately proportioned and placed—create a realistic image.

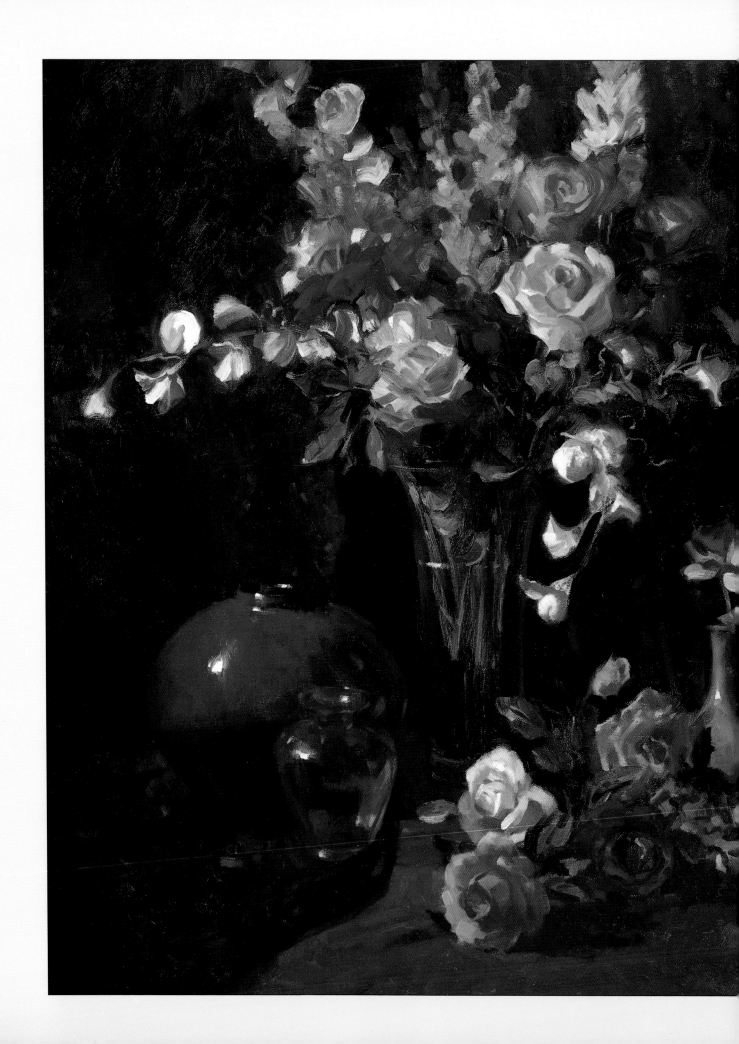

STILL LIFE PAINTING: INDOOR CHALLENGES

Still lifes are disciplined studies in color, values, edges, proportions, texture and paint quality. They teach valuable lessons because you have control of objects, lighting, time and composition.

You can spend minutes or days setting up a still life, and use the same props in various arrangements, with different surroundings. Gather objects that attract you and arrange them in relationship to each other. Create still lifes based on: subject, like a kitchen or hunting theme; color, such as complementary blues and oranges; and textural properties, like smooth surfaces next to rough. Start with simple subjects and work up to more complicated ones. The possibilities are endless.

ROSES AND RED VASE, 30" × 36"

Putting It All Together

Up until now you have simplified to a few general, explanatory color notes. Now break down the big shapes into smaller shapes, suggesting detail and finish, being careful not to destroy your foundation. Look for wonderful, subtle color changes, reflected light, halftones, highlights and dark accents that add vitality, variation and unity to a picture.

There is a visual dialogue that occurs between objects when colors reflect into each other. Softer edges tie areas together, while sharper edges accentuate an area.

Soften edges by carving smaller planes, for gentler transitions.

Pay attention to your brushwork and experiment with a variety of paint consistencies: long strokes, short strokes, thick paint, thin paint. Try using a palette knife to give variety to the surface.

CHALLENGE YOURSELF

As you progress, set up still lifes with objects that seem more difficult, for example, transparent reflective surfaces. Truly see their colors and shapes—the puzzle pieces that create reality.

FRUIT EXERCISE

Take one piece of fruit, such as a pear, and do a series. Work small; 6″ × 8″ or 8″ × 10″. Paint the pear on yellow, red, blue and green cloths. Set a task for the day. Change the lighting: top, side, backlighting, warm light, cool light. Concentrate on varying edges; push the color notes; exaggerate the planes. These can make a very attractive arrangement when framed and grouped together.

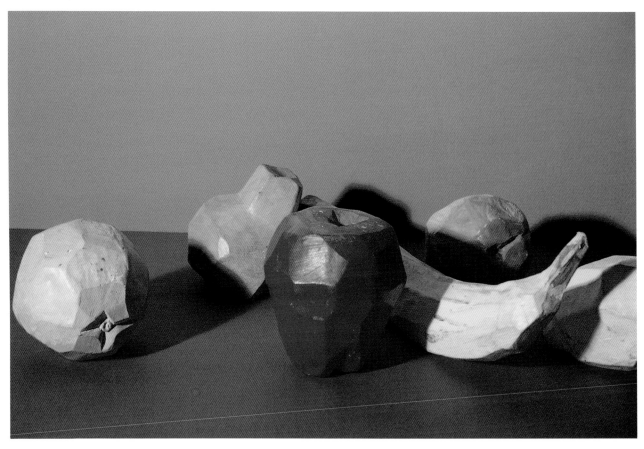

Visual Dialogue
Look for the dialogues between objects, background and tabletop to see their subtle influences on each other. The banana reflects into the apples, and the apple in front casts a shadow on the banana. The background color reflects into the top planes. Ask yourself which direction a plane faces to help determine its color.

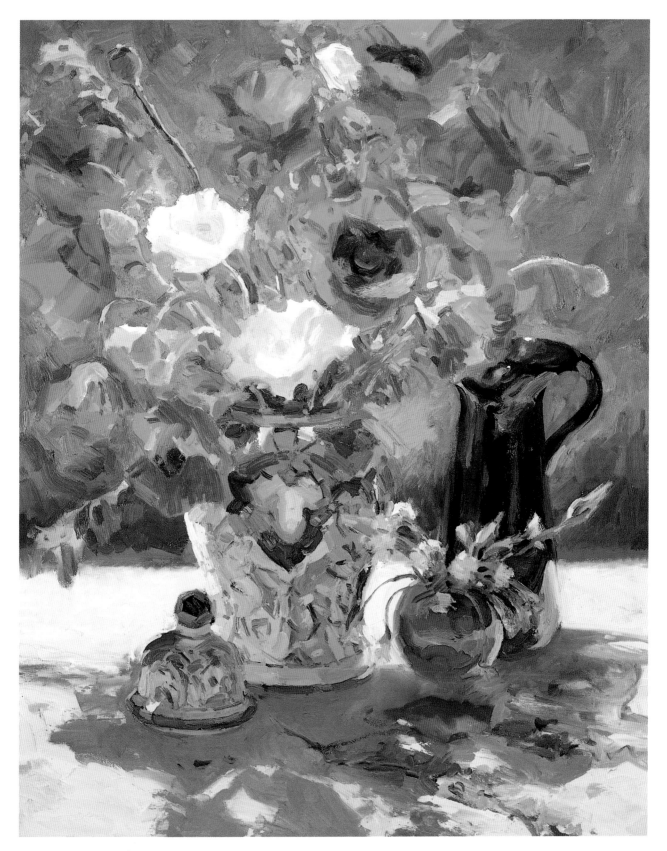

FIESTA FLORAL, 30" × 24"

LARGE AND SMALL SHAPES

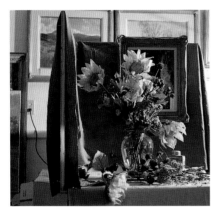

1. SUNFLOWER SETUP

A strong spotlight off to the right illuminates silk flowers, an old painting hung sideways, and dried weeds. The still life is arranged on a sculpture stand that can be raised or lowered as desired.

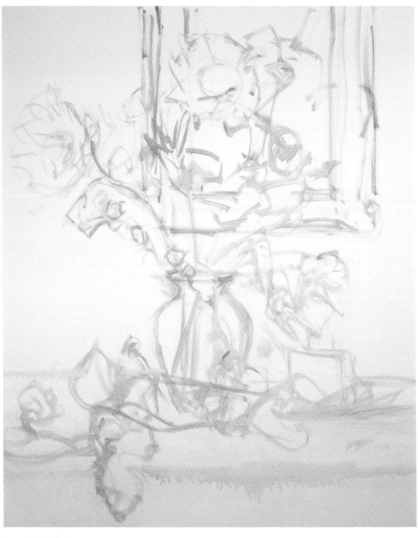

2. THE MAP

Draw in shapes, using a color suggested by the overall arrangement that will not overpower the final colors. This drawing is mainly a map that will be covered over later. Some subjects require very little preliminary drawing, while others need a more careful layout to avoid trouble later.

TRUST YOUR INTUITION

When all your practicing comes together and your painting abilities are on target, a painting often paints itself. That is, you work intuitively, your painting flowing almost subconsciously. When that happens, sit back and be thankful.

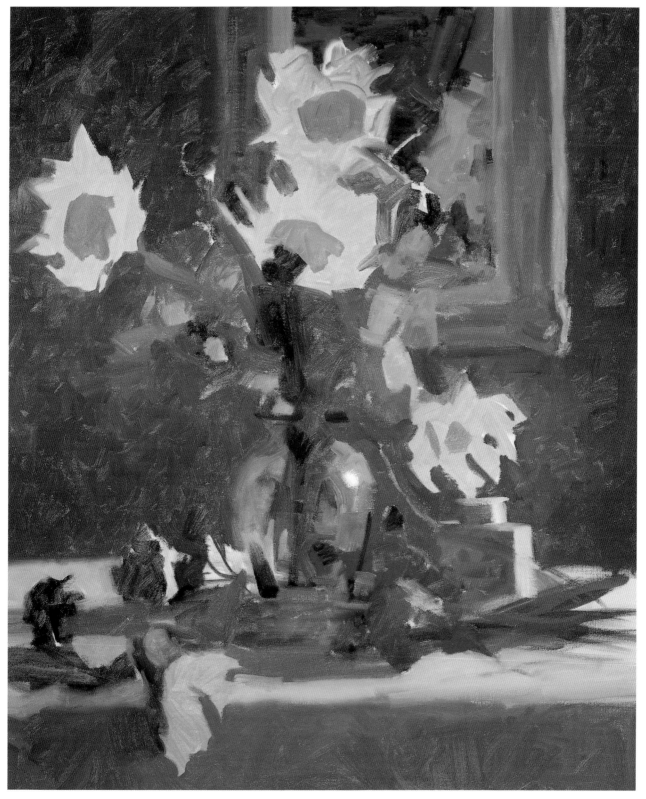

3. CONSTRUCT THE BIG PICTURE

When laying in the initial shapes and colors, try to respond quickly and intuitively, trusting your first impression. The color notes in the background painting have a richness and spontaneity that I barely need to adjust for finish. The background color is basically a solid tone with variation added from the start.

ELIMINATE THE UNNECESSARY
Squinting eliminates the unnecessary.

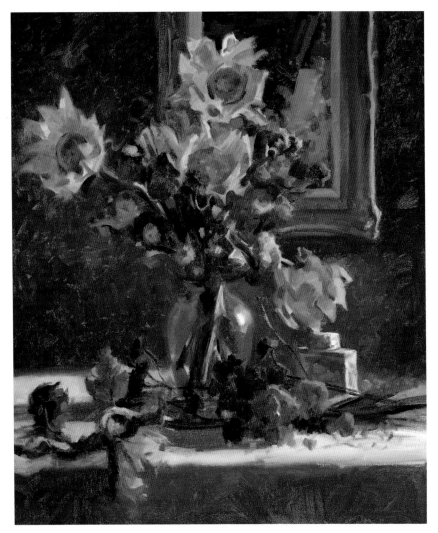

We imagine everything is in focus because we constantly shift our eyes. In reality, when we focus on a subject or area, we see the rest with our peripheral vision. So not everything needs to have equal emphasis in your painting, but you should emphasize your subject.

4. BREAK DOWN THE LARGER SHAPES

After the initial block-in, step back. Compare your subject with your canvas. What is the most obvious area in need of correction? How is your painting different from the subject? How can you break down the initial shapes further? Perhaps a shape's color goes gradually from warmer to cooler, or from lighter to darker. Move around the canvas without lingering too long on one shape. Make subtle adjustments to the original block-in, refining the shapes without destroying the general contrast and harmonies already established. Establish visual dialogues, such as in the background here. The lower-right sunflower reflects yellow light into the background, while the vase reflects a purple glow.

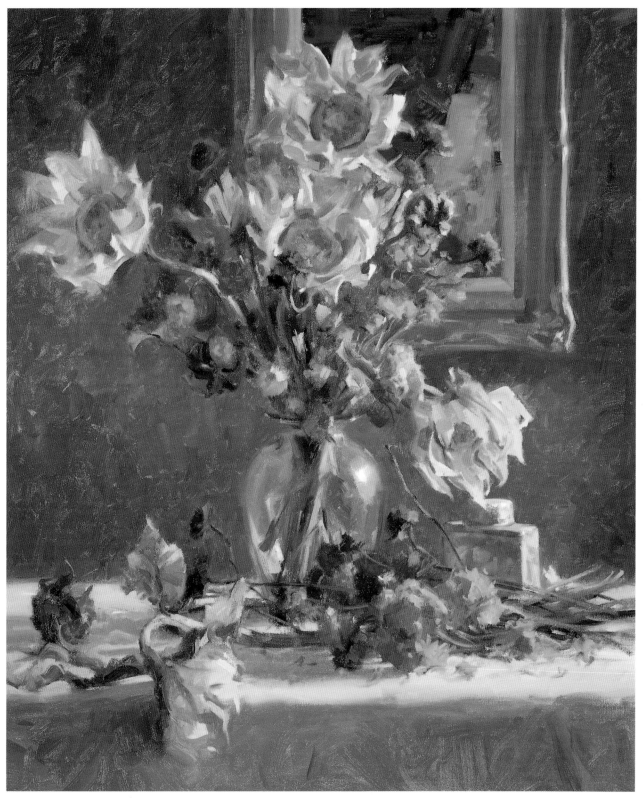

5. SUGGEST DETAIL

SUNFLOWERS, 36" × 30"

Continue to break the shapes down into suggestions of detail, periodically stepping back, or viewing the piece in a mirror. Don't overwork the painting. When there are no more adjustments or corrections needed, you are done.

Gallery of Still Life

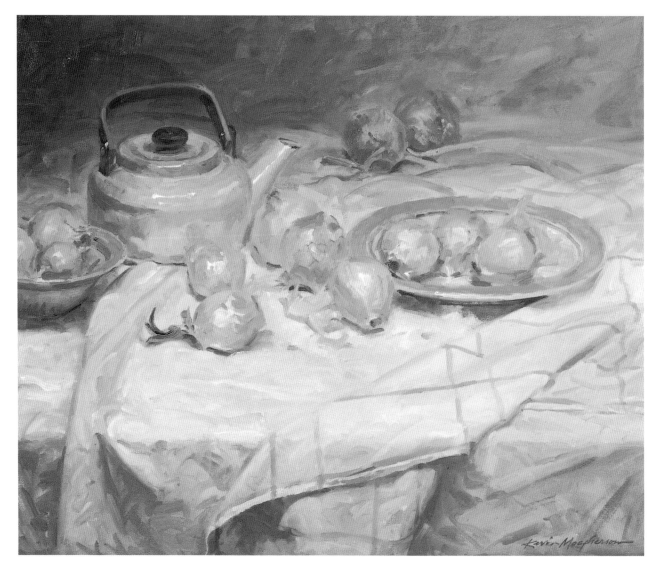

Delicate Color Change

The range of colors is very narrow here, but the questions are the same. Where is the lightest light? Darkest dark? In this case, the darkest dark is far from black. There are many slight color temperature changes with similar values. Set up a challenge for yourself. How about all yellow objects, or all black? Look for the variety of color changes within that general color scheme.

GARDEN PEARLS, 20" × 24"

KEEP ON LEARNING

All paintings are lessons for the next. It's an ongoing learning process, increasing skills for future works.

A Clear Illusion

Correct shapes and colors in the right places make glass and water almost magically. Take a look at the shapes and colors that create the illusion of clear glass and water in this piece. They are made up of puzzle piece of color. So get a glass of water, put a flower in it and get to work.

MOUNTAIN HOLLYHOCKS, 14″ × 11″

The Main Interest

What is the main focus of your painting? Direct attention to your center of interest, such as the onion at right in this piece. Shapes, soft edges and contrasts help direct the viewer's eye to it. You may want secondary interest, but avoid areas that draw too much attention away from the main focal point.

RED ONIONS, 12" × 21"

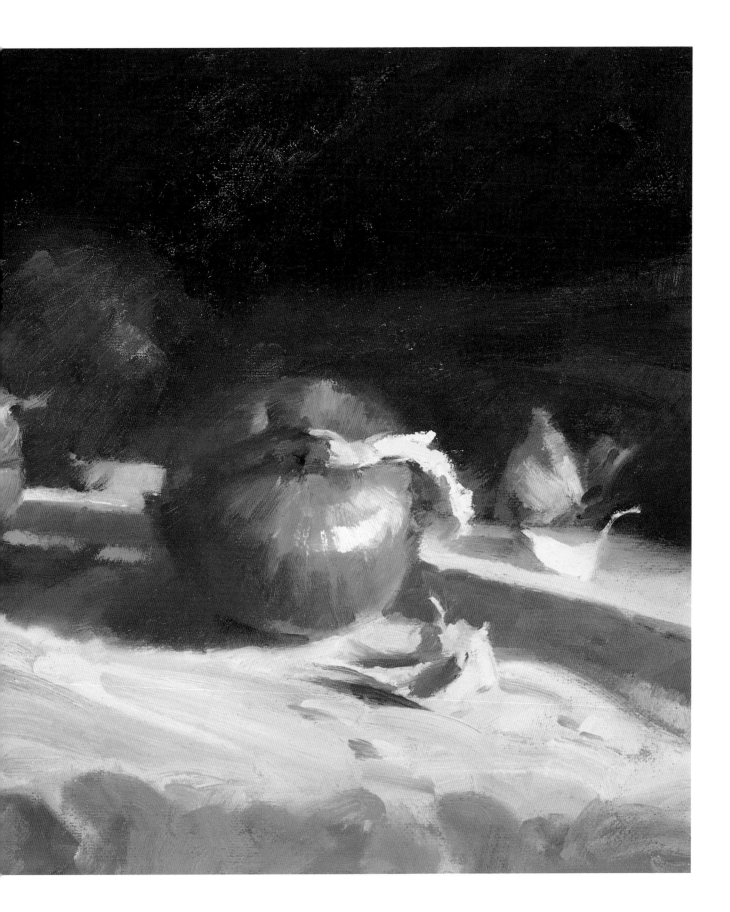

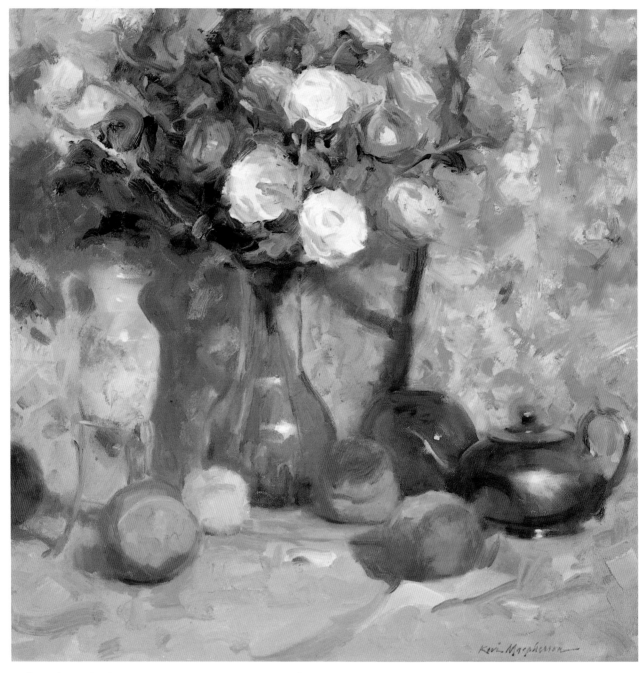

Soft and Hard Edges

Edges can help direct the eye, or hold its attention on something. The left side of the Venetian glass in this painting just melts into the background, while the harder right edge describes the form. Our minds fill in the rest. Since much of what we see is with our peripheral vision, we actually sense the things around our subject more than we accurately see them.

SOMETHING BLUE, 20″ × 20″

DIALOGUE OF OPPOSITES

Painting is a dialogue of opposites:
Unity/Variety
Warm/Cool
Thick/Thin
Light/Dark
Intense/Neutral
Round/Straight
Smooth/Rough
Large/Small
Soft/Hard

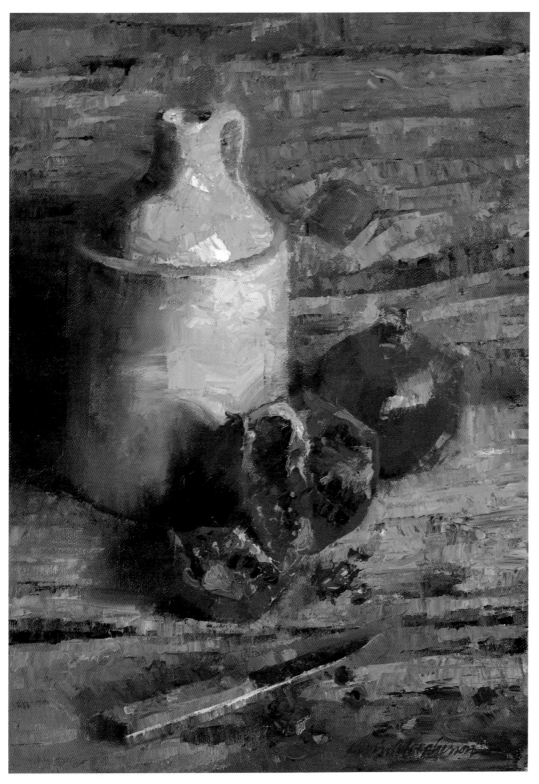

Light, Shadow and Technique

Warm light, cool shadows. Cool light, warm shadows. Most of my work outdoors
deals with warm sunlight and cool shadows from the blue sky. Artists build
their studios with north light windows, so they can have consistently cool light.
This is a wonderful situation. I used a palette knife to apply the paint, a method
that can sometimes become too monotonous. However, it is a great way to put
down color spots and not rely on brushwork to carry the statement.

POMEGRANATES, 14″ × 10″

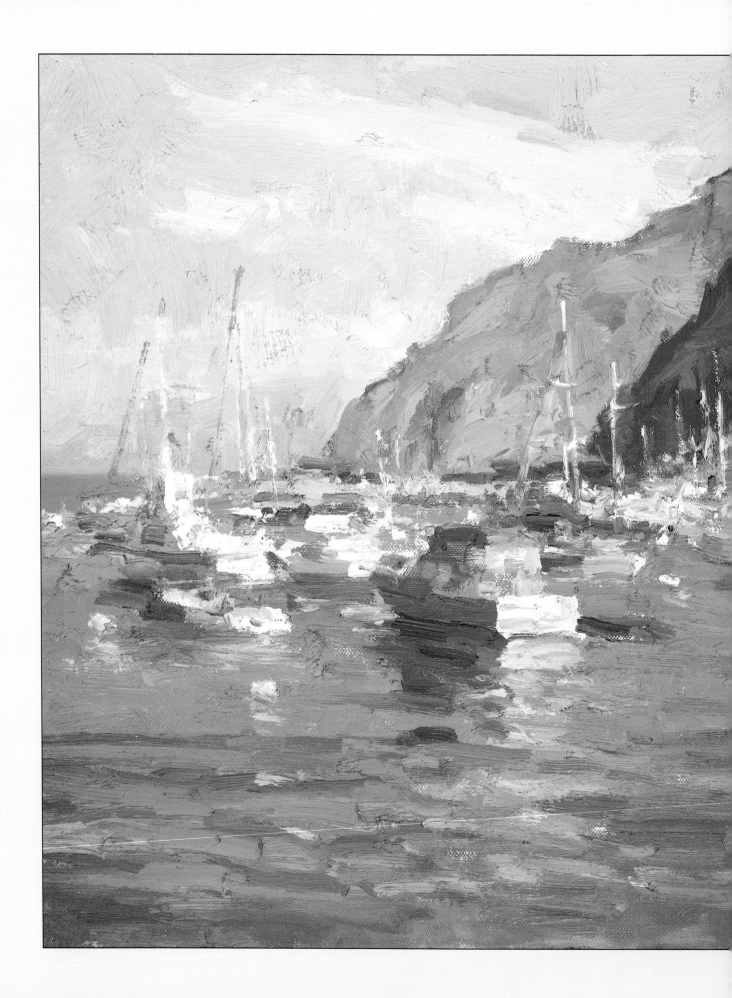

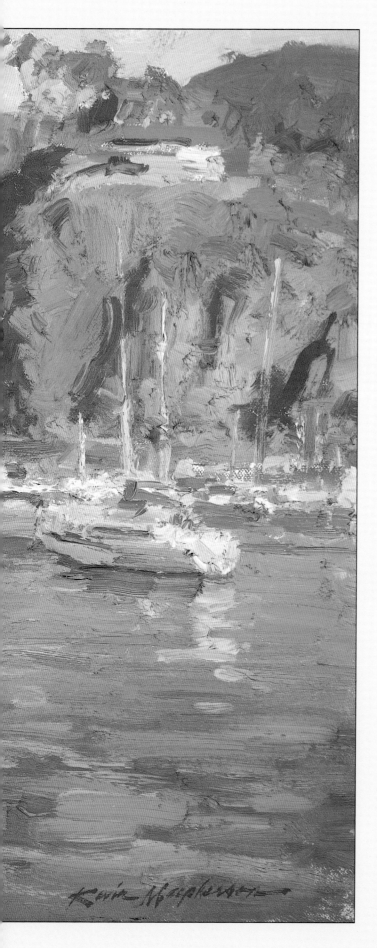

PLEIN AIR PAINTING: OUTDOOR OBSERVATIONS

Landscape painting is a timeless expression of human experience; man has contemplated the earth, sky and trees throughout history. The challenge of painting outdoors, *en plein air*, allows close observation of nature's light and colors, yet requires speed and memory to capture fleeting conditions. Nature displays endless moods; each day, hour or minute presents something new.

HARBOR LIGHT, 16"×20"

Approaching a Painting

Begin by finding a vantage point. Walk around the site with your viewfinder, examining various scenes until one "sparks" you. Sometimes you must search for a spot; sometimes a scene finds you. Trust your first impressions. Note what it is that attracts you—textures, color combinations, interesting shapes, exciting weather effects, striking contrast—and keep that in mind.

SETTING UP OUTDOORS

When you have found a scene that inspires you, position your easel and canvas as well as your palette in the shade, so that you can mix and compare colors in the same light. You may want to use an umbrella. If you set up under a tree, be aware of dappled light striking your setup, because it can become very confusing when comparing colors.

If you position your canvas in full sun, the bright light bouncing off of it will tire your eyes quickly, and any color note you put on will appear much lighter than it actually is; when you bring your painting inside it will be keyed down too dark. I don't recommend painting while wearing sunglasses. However, if you have no choice but to work with full sun on your canvas, try neutral gray sunglasses. They help compensate for the brightness, and reduce eye strain.

When you work on stretched canvas, the sun will sometimes shine through the back, creating a distracting shadow. In that case, cut a piece of cardboard about the same size and slide it behind your canvas.

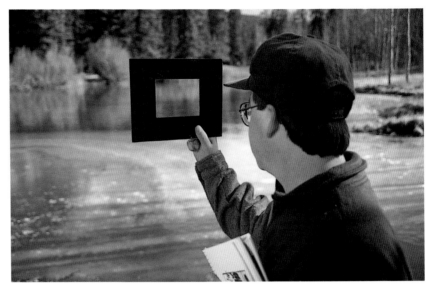

Outdoor Setup
My outdoor station includes my easel, a large folding palette, an umbrella and a cloth bucket filled with essentials.

PLEIN AIR Q & A

What do you want to convey?
What is your focus, or center of interest?
How long will conditions remain consistent?
What is the lightest light?
What is the darkest dark?
What is the easiest color?
What is the most intense color?
Where are the shadows?
How intense is the light source?
What color is the light source?
Where is the sharpest edge?

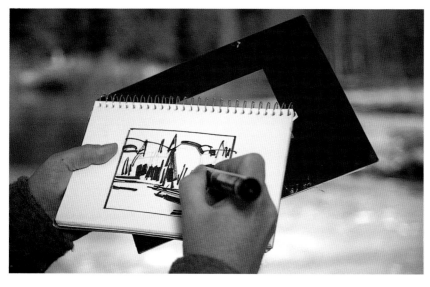

IDEA

You may be attracted to the beauty of sunlight, the grandeur of the mountains, the color of atmosphere or the tranquility of a scene, while another artist may want to feature the decorative patterns of trees. It's all individual. Consider your point of view, your reason for wanting to paint a particular scene.

ANALYSIS

Prepare yourself before you approach the canvas. Read the scene, analyzing the situation in terms of the concepts learned in previous chapters. Ask yourself as many questions as you can before putting down any paint. What are the major shapes? Is there a strong light-and-shade pattern? What planes face the sky, reflect its color and receive direct light? Figure out how you can break the composition down into big, simple shapes of flat color to construct your painting simply and strongly from the start. Do a few black-and-white sketches on paper in order to determine the arrangement of the composition, and to establish the light-and-shade pattern.

MEMORY

While you are painting, include elements and color notes that reflect your original idea, and edit out areas that are contrary to it. A scene may take only a second to inspire you, but it takes more time to reproduce it. Nature's action comes and goes. If it chooses to move or change, you must remember the original idea, colors and light that interested you. It is not always easy to hold on to that moment, but that is your task.

So memory takes on a very important role in *plein air* painting. Every stroke you put down is really done from memory. You look at your subject, remember what you saw while mixing, and apply your color note. The more you paint outside, the more your memory skills will develop.

STAND BACK

Stand a good distance away from the canvas as you work, with your arm stretched out. This way, you can see your painting and the scene simultaneously. Sitting down while painting may be comfortable, but it hinders you because you tend not to get up much once seated. You need to step back often to compare your canvas to the scene.

ANTICIPATION

Also try to anticipate what will happen. For example, will clouds come too soon and change the light? If so, don't chase the light, or any other fleeting conditions. That is, when painting a scene that changes rapidly, you must know when to stop portraying what's in front of you and continue to realize your idea, sticking with the effects of nature you want to portray. If you cannot retain the information that originally inspired you, stop and set up at the same time tomorrow, or when conditions are similar. You want to remain faithful to your original idea.

DEMONSTRATION
LIGHT AND SHADE

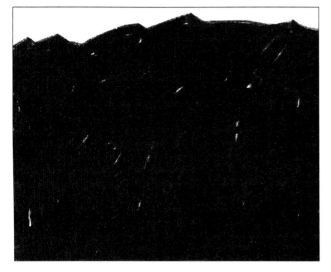

1. VISUALIZE THE SILHOUETTE

The biggest contrast in the landscape is between the sky and the land. The sun and sky are usually lighter than all natural elements on earth because the source of light is the sun and the sky. If the day is sunny, the light is warm. If it is overcast, the light is cool.

2. LIGHT AND SHADE

The shadow family and the light family are the second most obvious contrast. On your sketch pad, block in all shadow areas with black marker. Throughout the painting process, the shadow family should remain darker than the light family. Don't destroy this relationship.

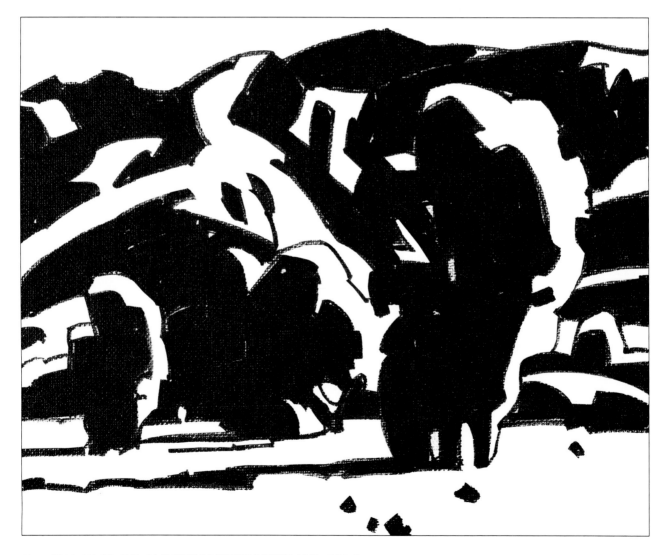

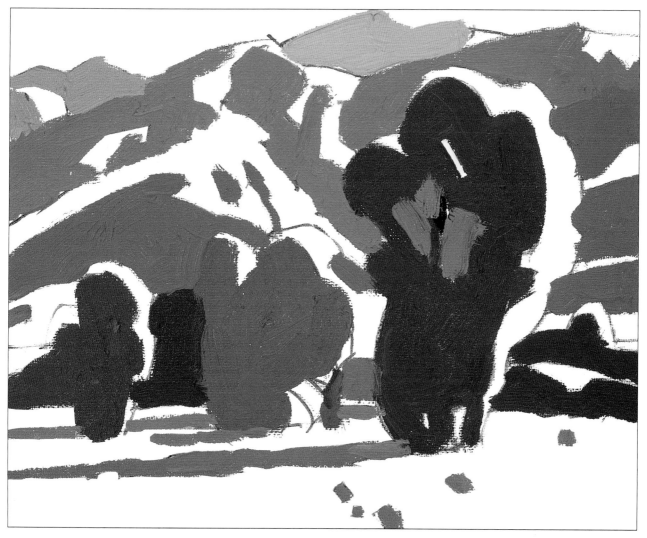

3. COLORFUL SHADOWS FIRST

Once you establish your value range with lightest light and darkest dark, it is best to establish the shadow pattern.

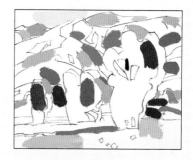

ORGANIZATION
Applying color notes in a haphazard way, though they may be correct, makes it much harder to judge relationships. Compare this example to steps 3 and 4, which are organized and under control.

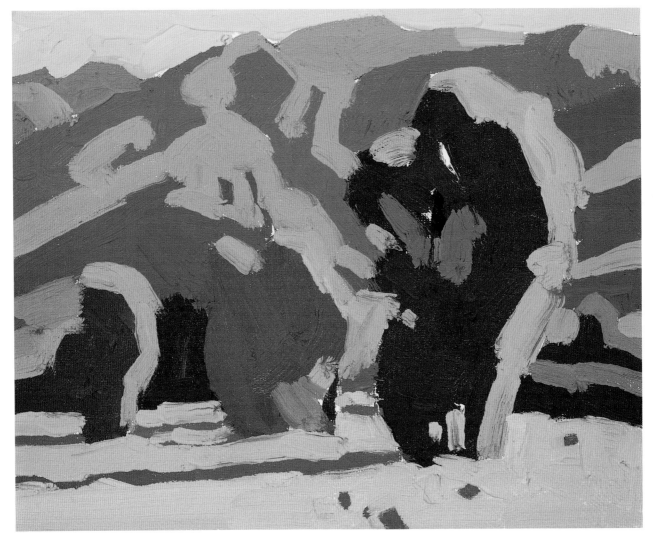

4. FILLING IN THE LIGHTS

Cover the canvas with clean color notes, making sure the painting maintains the silhouette established in step 1, and the light-and-shade patterns established in step 2. If it doesn't, make corrections so that it does.

HINT
Leaving the sky for last keeps you from painting it too dark, which would make you paint the land even darker. Key the sky to the land if the land is the main subject. However, when painting a sunset or featuring cloud patterns, do the sky first and key the land to the sky.

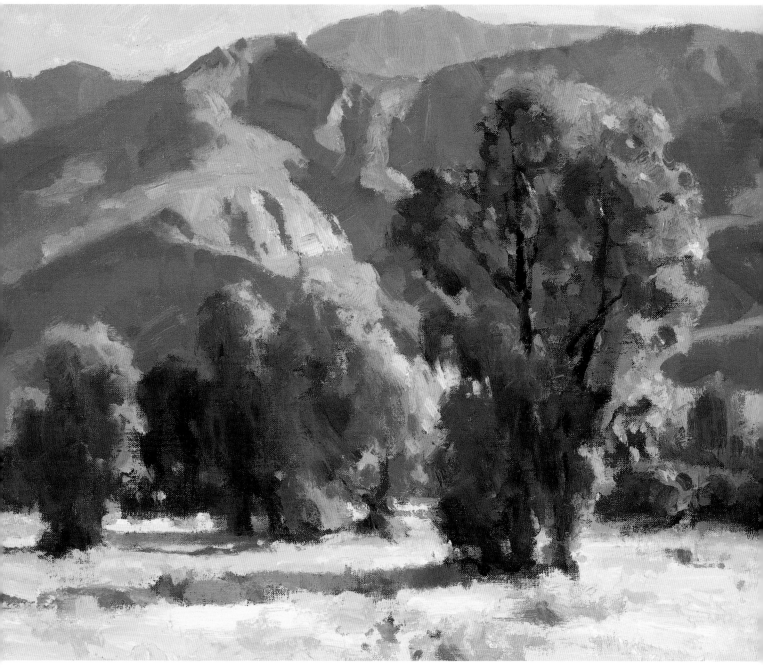

5. THE FINISH

Once the overall color pattern is established correctly, look for subtle changes and variations within shapes. Divide the larger masses into smaller ones, if necessary, without destroying the basic shapes. Then step back, turn away, walk away, rest your eyes, take a deep breath or wash brushes. When you are refreshed, come back to the painting with a renewed sensibility, and add finishing touches.

The more you learn, the more you know. The more you know, the more you know you need to learn more.

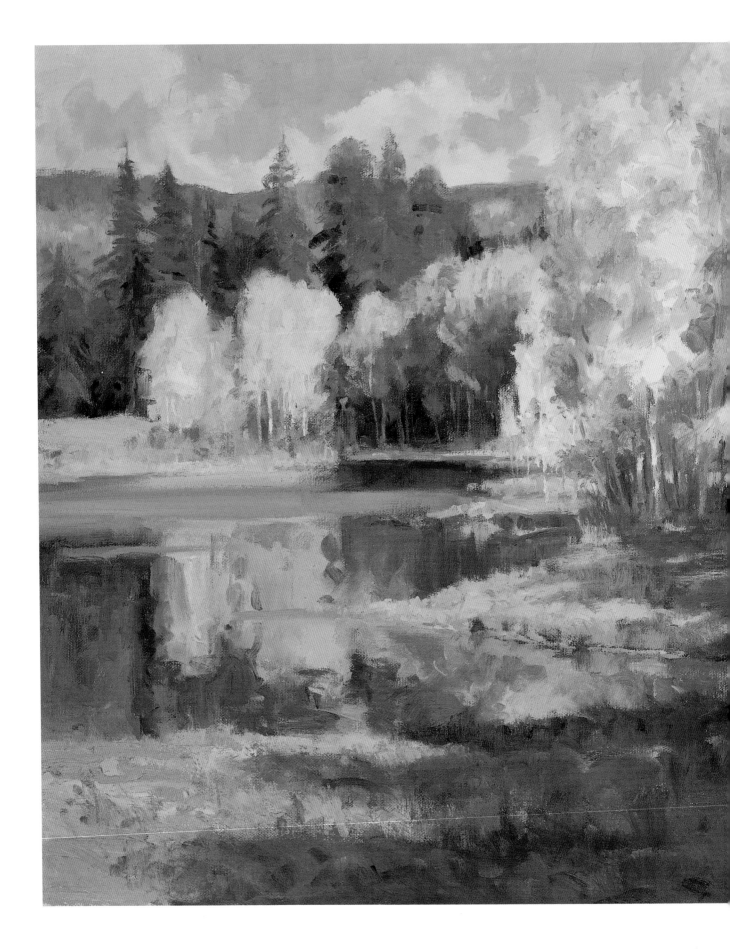

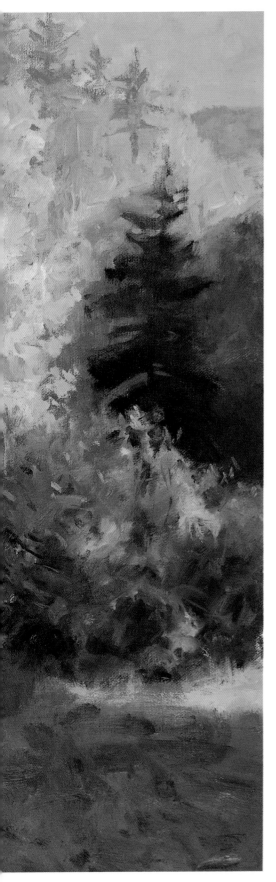

PICK A THEME

A subject that you become intimate with can provide endless observations for paintings. For example, a small pond not far from my door has lent itself to numerous compositions. Find a setting in your own neighborhood and look for different ways to describe it. Seasonal changes and various light effects, along with your moods, add up to endless possibilities. Painting everyday surroundings challenges you to look closely, know your subject, respect it and find its subtleties. Be inspired by new sensations, and try not to think about how you painted a subject before. Always look for new ways to express yourself.

Fluid Shapes
Water is no more difficult to paint than anything else, because reflections follow general principles. Dark objects reflect slightly lighter in water, while light objects reflect slightly darker. Just paint the color notes you see; the water will create itself and read correctly. The edges of shapes let you know what type of water it is: still, moving, turbulent, etc.

FULL GLORY, 20″×24″

EN PLEIN AIR

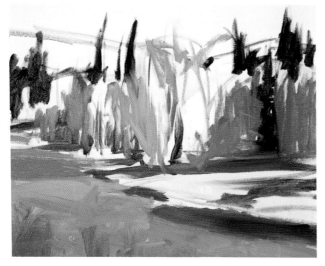

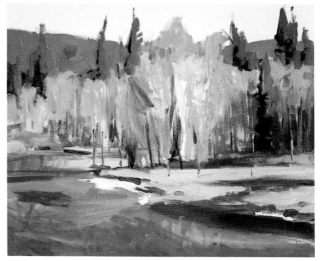

1. A FREER START

As you progress and become more accurate, you may want to be freer with your lay-in. However loosely you choose to paint, maintain the shapes of the shadows.

2. COVER THE CANVAS

Cover the canvas as quickly as possible, without worrying about finishing any one area. Be concerned with the big color notes.

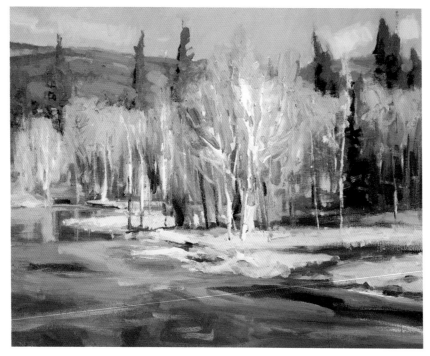

Work all over the canvas at the same time.

3. CARVE OUT THE DRAWING

With your major shapes blocked in, carve out the branches and add variation to all the shapes. If the light changes, stick to your original plan.

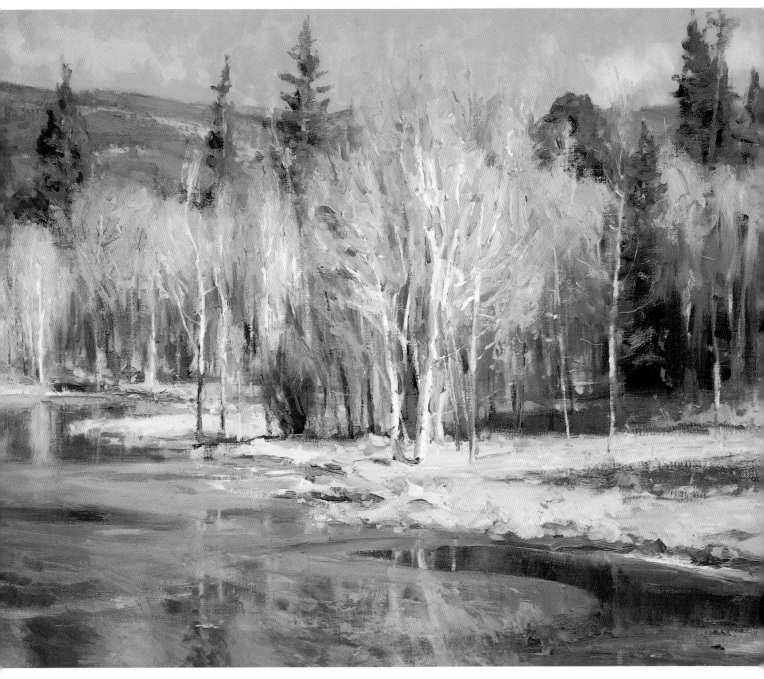

4. FINISHING TOUCHES

Stepping back helps you visualize your painting more objectively. When I realized the evergreens were mimicking each other, I made one smaller and more rounded. A hint of snow in the background hills helps add movement and space by repeating the foreground snow color.

Did you convey your idea, concept, mood?

Gallery of Plein Air

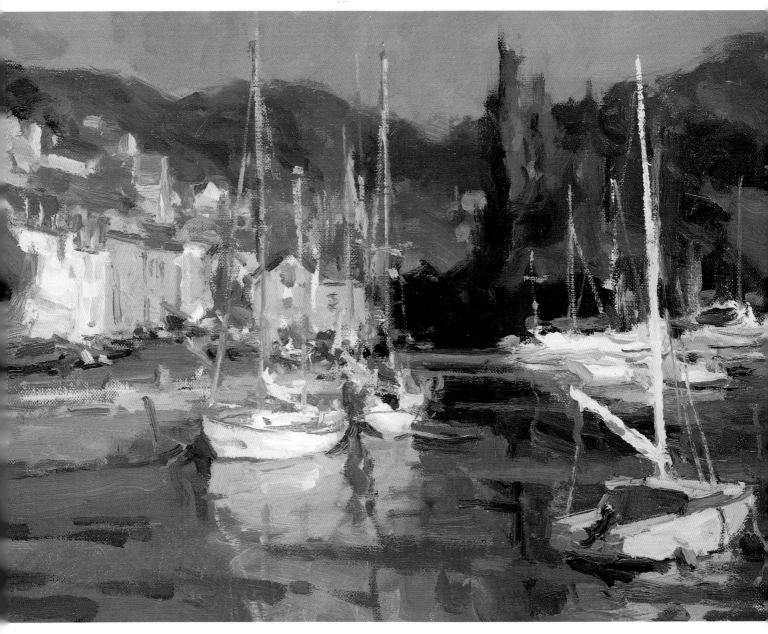

Impressionistic Strokes

Many times, the subject tells you how to paint it. Certain subjects lend themselves to be painted in certain ways. Some days I paint boldly, other days delicately. I believe it should be this way, because it keeps your process from becoming a formula.

PONT AVEN, 12″ × 16″

Get excited about your subject. Paint with enthusiasm.

My Idea

Upon awakening and looking out my living room window, I immediately saw this scene of fresh, gentle snowfall, and I knew I had to paint it. The subject chose me. The blue jays were waiting for their morning seed. I painted them for secondary points of interest, keeping the viewer involved in the painting longer. The gestural quality of the tree limbs laden with snow attracted me. They looked like a dancer with arms outstretched. It was important to compare the white snow on the branches to the snow color on the ground.

BLUE JAYS, 20″ × 20″

Set a task for the day's work.

The Spark
This lone tree spoke to me. I was intrigued by the rhythm created by its struggle with the desert elements, and by the warm glow of the desert light. People often clue me in on a beautiful scene that I must paint, but it is not the scene as much as the colors, values and shapes that combine for an emotional response from the artist.

SCOTTSDALE SUNSET, 16″×20″

NATURE AND YOU

Artists' moods vary as much as those of nature, so your own feelings about subjects come into play. Choose subjects that attract and inspire you. Try to express qualities of nature that touch you personally, trusting your intuition more than formulas and preconceptions. Be sensitive to your surroundings. Let yourself be like a child: curious, full of wonder and imagination. Your painting is part you and part the scene.

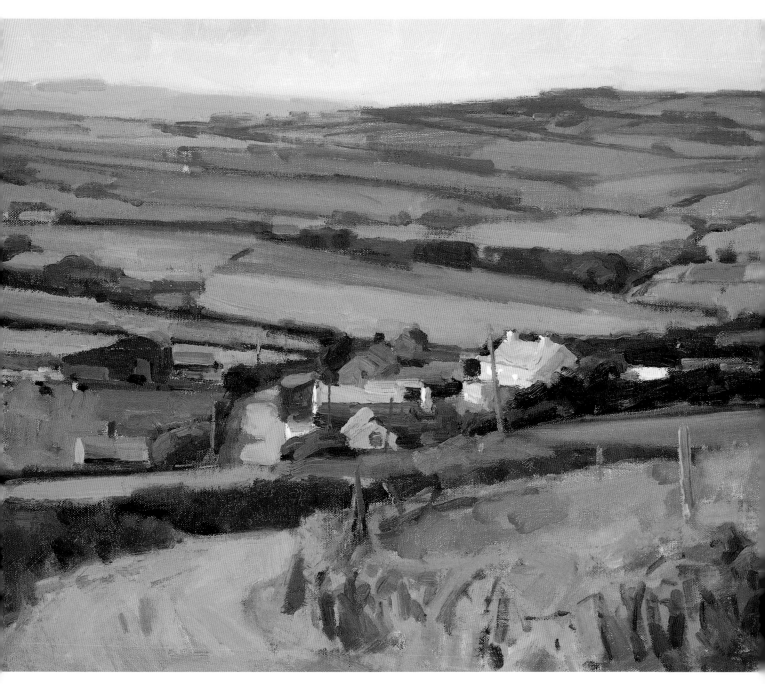

Atmospheric Perspective

In the foreground, textures and warm colors advance. The illusion of depth is enhanced by overlapping elements, less value contrast, and colors neutralizing into atmospheric blue-grays as they go deeper into space. Think of the atmosphere as sheer curtains. Because the air is dense with moisture particles that reflect light, as things recede into the distance, there are more veils of atmosphere to look through. The more layers there are, the less we can see. If you paint what you see, comparing shapes to each other, you will automatically get the feeling of atmospheric perspective.

EMERALD PASTURES, 16″×20″

Texture comes forward.

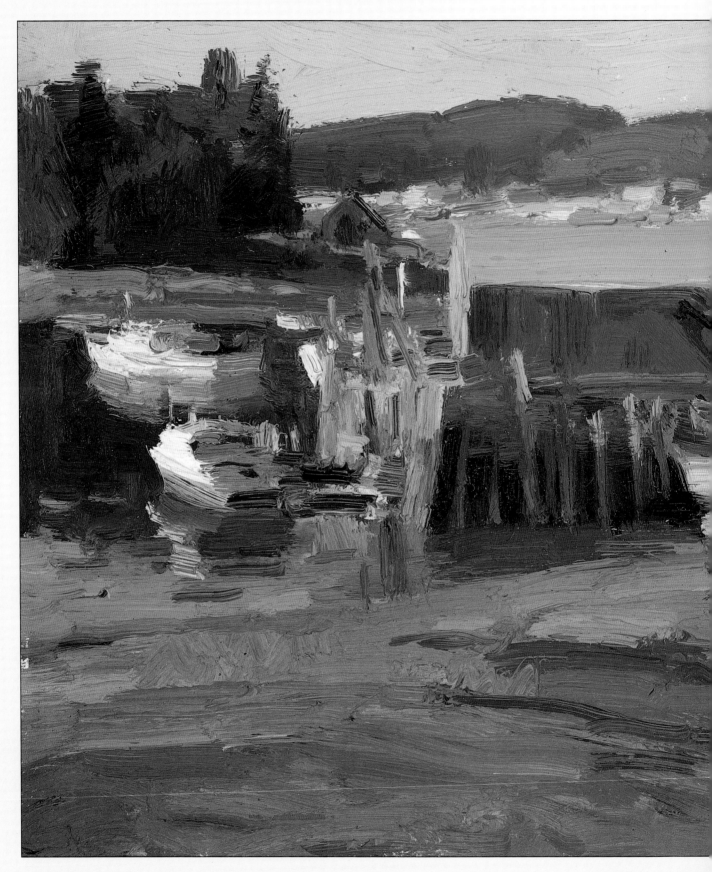

PORT CLYDE, 6″×8″

POCHADE PAINTING: SMALL AND BEAUTIFUL

*P*ochade (pronounced poe-shod) is the French word for rough sketch. It is a painting done very quickly, with few strokes. Taking nature this way, a small bit at a time, is convenient and produces fresh, beautiful results. For many years I have pursued most of my outdoor oil paintings in miniature, usually on 6″ × 8″ panels.

Get Small

Painting small is not new; many great painters have taken to the field with this approach to gain information for their studio works. One of the first artists to seriously do this, painting hundreds of small oils, was John Constable (English, 1776–1837), whose small sketches are greatly admired. Joseph Mallord William Turner (English, 1775–1851) also painted small sketches outside for the direct stimulus of the scenes. Turner painted many outdoor *pochades* around 1810, using these sketches and his uncanny memory to produce larger works. Doing large paintings on location presents finishing problems. In the early years, even the famous Impressionist painter Claude Monet (French, 1840–1926) had a difficult time finishing large oils outside He would go out many times to work on one scene, which made it difficult to finish a large painting. So if we work small, we can finish easily.

These artists paved the way for many others to paint outdoors using compact *pochade* boxes that combine easel, palette and supply storage in one portable unit. They come in a variety of styles and sizes. A *pochade* box can be attached to a tripod for convenience, and smaller ones may have a thumb hole in the bottom for holding by hand.

TIME FLIES
Working small has many advantages, the first of which is speed. Since time is a crucial factor for many scenes, doing small, *alla prima* paintings (paintings finished in one session) is sometimes the only way to capture very fleeting moments such as storms, sunrises

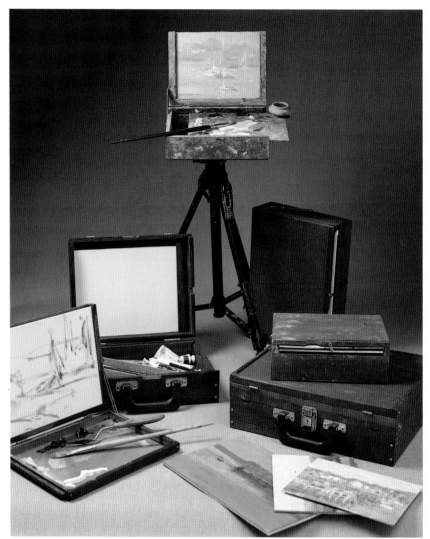

or boats on the sail. It is often essential for capturing the fleeting effects of light. The most dramatic lighting often occurs in the early morning and late afternoon, when the sun rapidly changes colors and shadows. Being able to paint quickly at such times is a must.

Since time is often a major factor in the lives of many students who have regular jobs and family responsibilities, painting small can be an important way of accelerating artistic growth. It enables you to complete more paintings in a shorter time, yet you can learn as

much from doing small paintings as from larger ones. When you step up to a small canvas to try something new every day, rather than working and reworking a large painting for weeks, you see progress. You learn to master techniques, such as brushwork and texture, which boosts your confidence. Painting on a small scale also forces you to ignore inconsequential details and look for larger shapes, broader color relationships and overall composition. It gives you the ability to look at a scene as a whole.

The Painting Process

Portable equipment lets you set up and be ready to paint in minutes. Working with a *pochade* box, you'll learn to paint small, fast and light. It will make you a better painter, continually pulling you closer to capturing the fleeting light and color of the landscape.

Start by picking an outdoor subject that is easy to capture or one that is small in scope, such as a tree, puddles or the side of a house dappled with light. Pick something that makes you think "I can do that." You may want to do studies of that subject under a variety of circumstances. If you can, strategically situate your *pochade* box so that you're not facing the sun, or subjected to the glare of wet paint.

Unless your subject is very complex, forego a detailed sketch on the panel. Merely indicate the important placement of shapes enough to maintain accuracy. I find it easier to focus on the general relationships of the shapes in a composition when I'm working on small panels, perhaps because it's easier to take in the entire painting in one look.

Use the largest brush you can, even though maneuvering the brush on a small surface can be tricky. You want to see and paint the larger patterns of light, shadow and color. You want to capture the essence of the scene, not the small details. A larger brush can suggest details without overworking the image. Besides, a small brush negates the advantages of working on a small panel.

Paint rapidly, but thoughtfully. Consider the purpose of every stroke. Keep in mind what you want to convey with the painting, and concentrate on making brush marks that move you closer to that goal. Push yourself to cover the entire panel without getting bogged down in details.

Frequently step back and view the painting from a distance, so you can see it as a whole. Don't do a lot of blending; it's an invitation to fussiness.

NO SMALL EFFORT

Despite the small size of *pochade* paintings, there's no reduction in the mental energy expended to produce them. I paint rapidly, working intuitively and responding emotionally. A lot of effort can be devoted to a small format, but the dialogue that occurs between the landscape and the artist is exhilarating. A 6″ × 8″ painting can have an uncanny monumentality, or a gem-like quality.

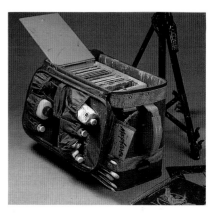

Studio in a Bag
Everything, except my umbrella and tripod, fits neatly in this gym bag: brushes, paint, turpentine, tissues, trash bags and 24-panel drying box. The drying box was made to fit inside with room for the *pochade*. A sketch book fits into the locker bag pockets. The kit is convenient for car or air travel. It made weeks of cold, damp, dark winter days painting in Ireland possible for me. In and out of small cars, stays in bed-and-breakfasts, and on site in frosty weather, my studio-in-a-bag was always handy, wet paintings tucked safely away.

Paint as fast as you can and still be accurate.

ESTABLISHING AND REFINING SHAPES

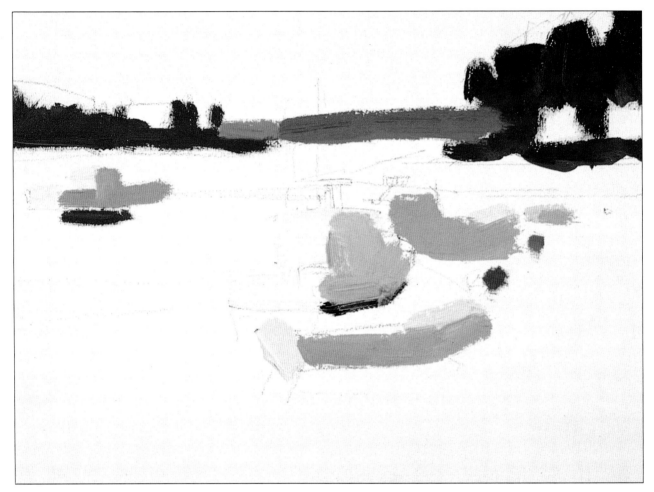

1. ESTABLISH THE BIG SHAPES

Begin with a quick sketch, and map out the important shapes with a large brush. Find the lightest lights. Using bold strokes, place your first color notes, here the warm whites of the boats, flatly and simply. Compare the slight color temperature changes of each other light shape. Next indicate the darkest dark, concerning yourself with the accuracy of the color note rather than carefully filling in the drawing. The drawing is just a map. You will quickly lose it, because you are constantly going over it, drawing proportionally placed shapes with your brush.

Make quick, direct decisions.
Time is short.

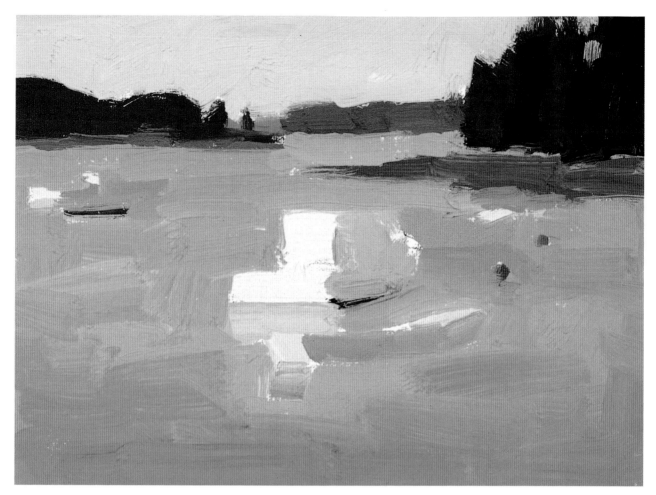

2. PAINT THOSE SHAPES

Cover the entire panel with an arrangement of flat shapes, painting the colors and values as accurately as possible. Each color helps you judge the next one.

OBSERVE CHANGES

Each subject more or less directs its own painting process. Boats will often move the whole time you're painting them, and water changes patterns, so always be observant. As your work progresses, pick the patterns that best help the painting. Work on one boat while it's at the angle you want, then go to another as it changes.

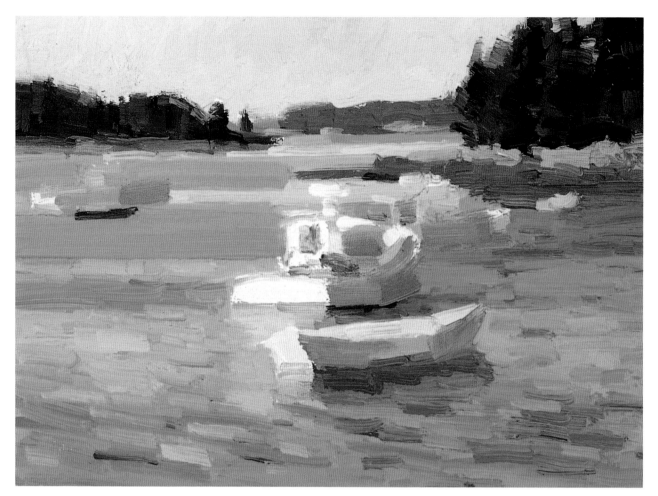

3. REFINE AND MODIFY

Once you have the entire panel covered, step back and evaluate your color choices. Examine each shape, asking yourself if anything needs to be lighter, darker, warmer or cooler. Then make the adjustments. Modify larger shapes, such as the background trees, with smaller touches of color. Look for nuances and variations. Adjust values, soften or sharpen edges, and clarify any confusing areas. Break down the original shapes by painting more simple shapes within them, being careful not to destroy their general colors and values. Add as much variation as you please, but think it out. Less can often say more.

HOUR-A-DAY CHALLENGE

Spend an hour a day for three months painting one 6″ × 8″ painting every day. That's nearly one hundred paintings! Paint from life or memory, and don't worry about finishing. Number the backs of your canvases to mark your progress. I guarantee you will improve, and your paintings will naturally look more finished without your having to consciously think about it.

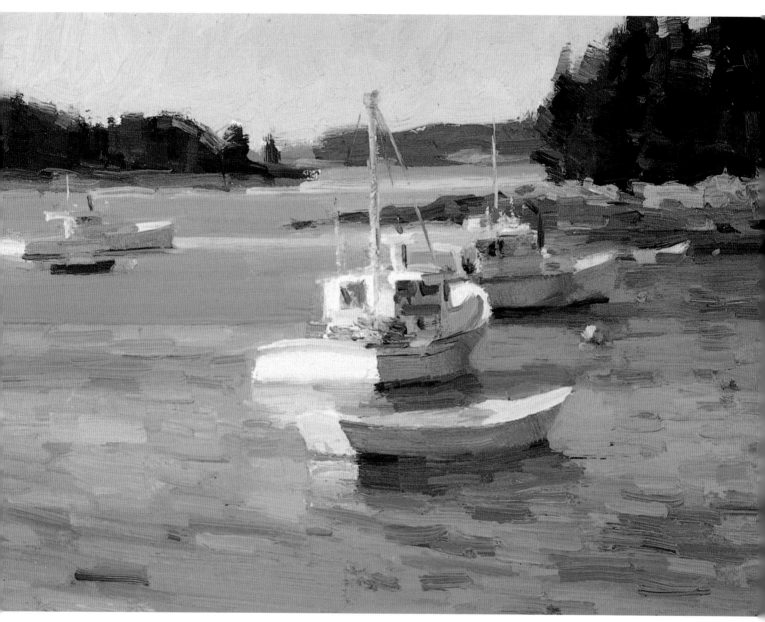

4. JUST ENOUGH DETAIL

Carefully thinking about every stroke and using the largest brush possible, add only those details (smaller shapes of color suggesting what you see) needed to define the subject, such as the gear on the boats. Continue to refine the painting, going from shape to shape, working big to small. Just as you divided the panel into a dozen or so shapes, you can divide all those into however many you choose. Concern yourself with soft and hard edges. Very little detail is necessary. If the shapes, color and values are right, the correct impression is already there.

If it is correct, leave it alone.

DEMONSTRATION
ARRANGING ELEMENTS

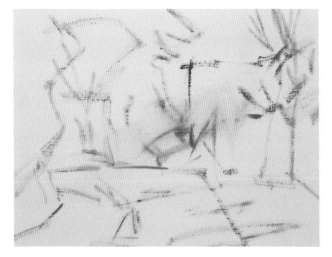

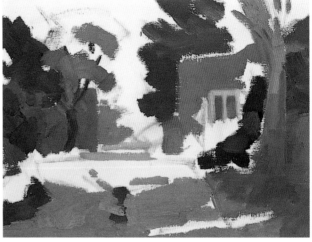

1. ARRANGE THE ELEMENTS

Quickly map out the important elements of the composition. Being in control from the start makes the painting process easy.

2. COLORFUL SHADOWS

This composition already has a feeling of light with only the color notes of the shadows laid in.

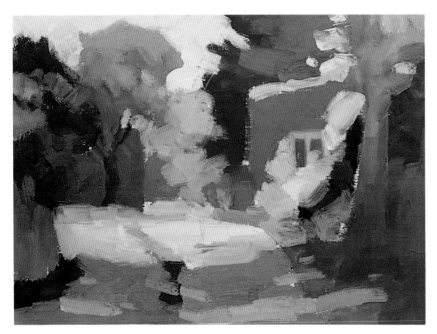

3. FILL IN LIGHTS

The overall light-and-shade pattern is established.

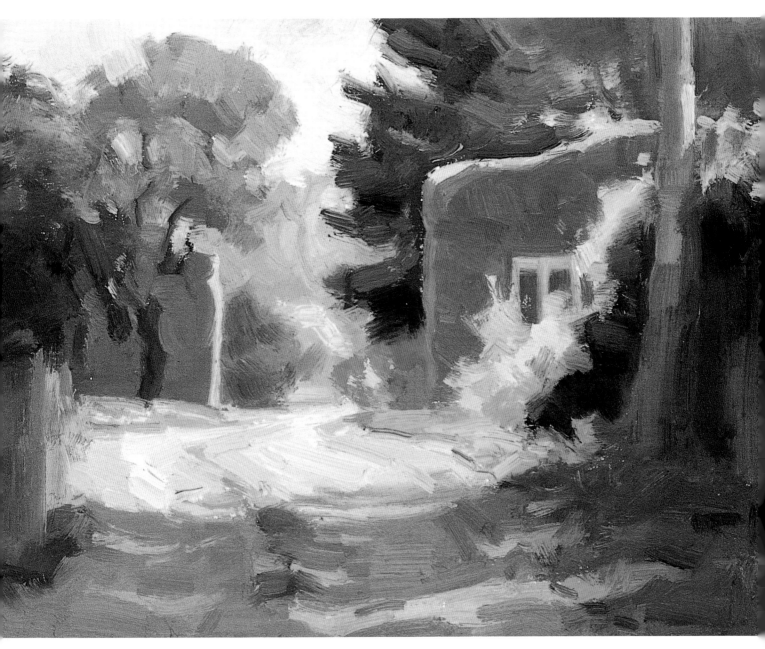

4. ADD VARIETY

Complete the painting with subtle
warm and cool variations, as well
as attention to the edges of shapes.

SANTA FE ALLEY, 6″ × 8″

NO MUDDY COLORS

Wipe your brush with a tissue
after every stroke, and scrape
your palette frequently with a
palette knife.

Gallery of Pochade

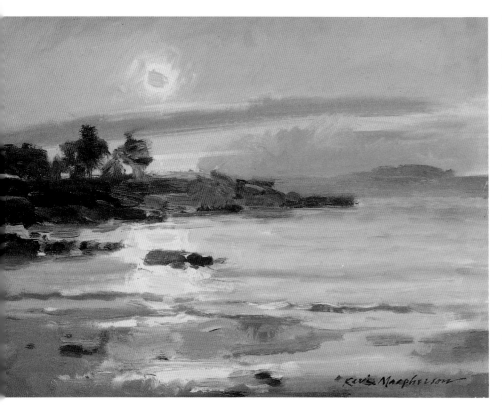

Trust What You See

Mom always said, "Don't look directly into the sun." It's not advisable, but so intriguing. This Maine sunrise moved so quickly, I had to race to capture it and the colors reflecting on the gently moving water. I painted the center of the brilliant sun Winsor Green and white—something I never would have imagined in the studio. I saw it and trusted my eyes. When completed it gave a feeling of intense brilliance.

WIPE THE SAND FROM MY EYES, 6″×8″

Don't discount it because it came easily.

Nature's Subtleties

Every sunset or sunrise takes on amazingly different harmonies. Photographs taken of this scene do not reveal any of the subtle color temperature and value changes I captured from life, especially in the sky. Painting from life brings out unexpected combinations and challenges; that's what keeps me coming back.

ALBONEGAN MORN, 6″×8″

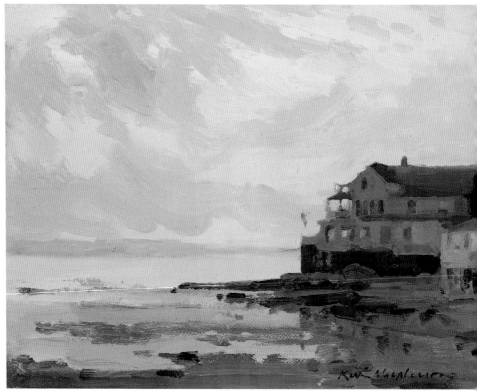

Speed Skills

My speed skills from endless *plein air* paintings are so important for situations such as the one when I did this piece. The wind was blowing fiercely at Dana Point, California, and the last hour of sunshine was in front of me. As I sat below a cliff, bracing my wind-blown easel, a pregnant mother with her young child passed by ever so quickly. I jotted their gestures down within seconds, and left them alone. Sometimes you win and sometimes you lose. I think I caught this one.

SOLITUDE, 6″ × 8″

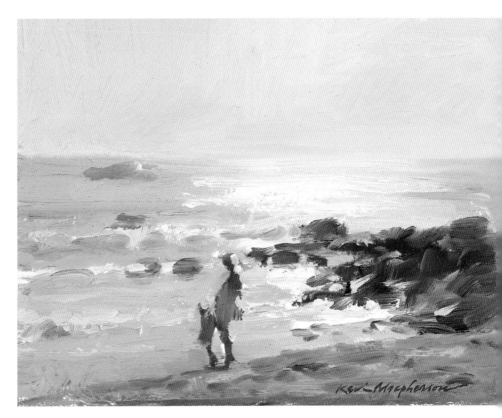

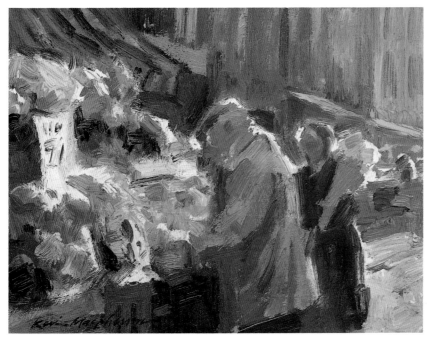

Simple Color Spots

In this piece, I tried to very loosely capture the early morning light of the Irish outdoor market. However, the lack of detail does not diminish my memory of colors, light and chilly air that day. The faces are just simple color notes, no details, but they are still believable. Perhaps more detail would have taken away from the whole.

DUBLIN FLOWER MARKET, 6″ × 8″

A Big Quality

With simplification and organization, a small canvas can have a big composition.

LA PLAZA, PUERTO VALLARTA, 6″ × 8″

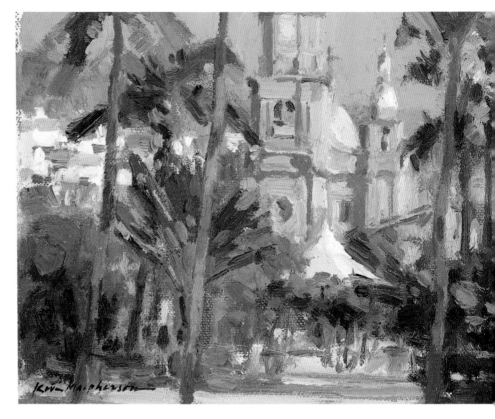

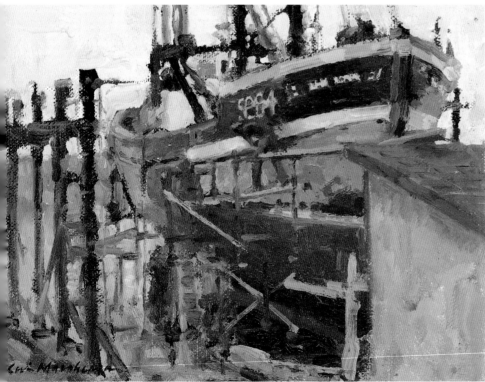

Oil and Water Don't Mix

Oil paint can be a benefit in inclement weather. As soon as I set up for this piece it started to drizzle. At times the rain turned into quite a heavy downpour. Passersby thought I was quite foolish painting in the rain, but oil and water don't mix, so I was able to do it!

SUMMER COAT, 6″ × 8″

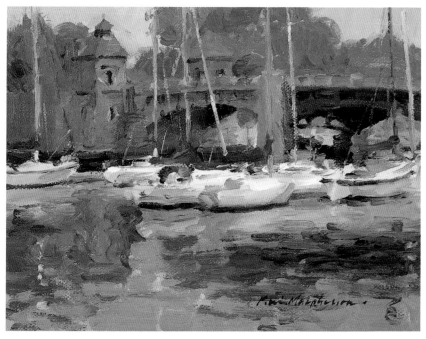

Gray Day Beauty

Gray days create patterns of dark, middle and light value shapes that are not as obvious as those found on more sunny days.

BRIDGE TO GLEN ISLAND, 6″ × 8″

Fleeting Light and Color

Painting small brings you closer to capturing nature's special moments. Fading light and fast-moving sailboats such as these are quite a challenge.

BOSTON SKYLINE, 6″ × 8″

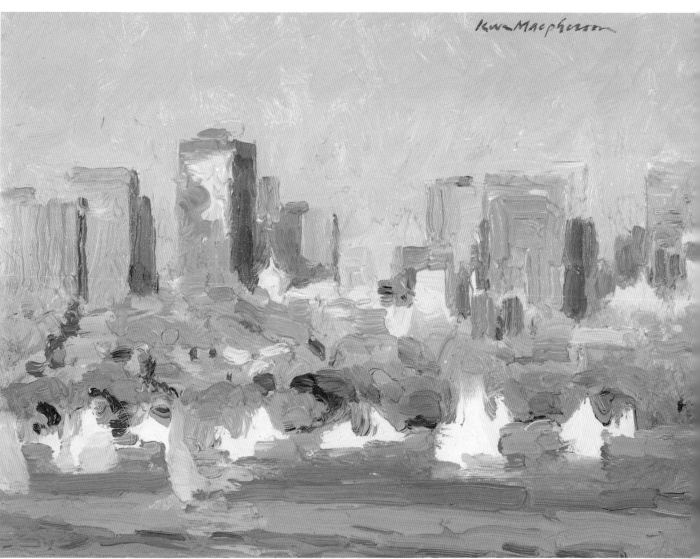

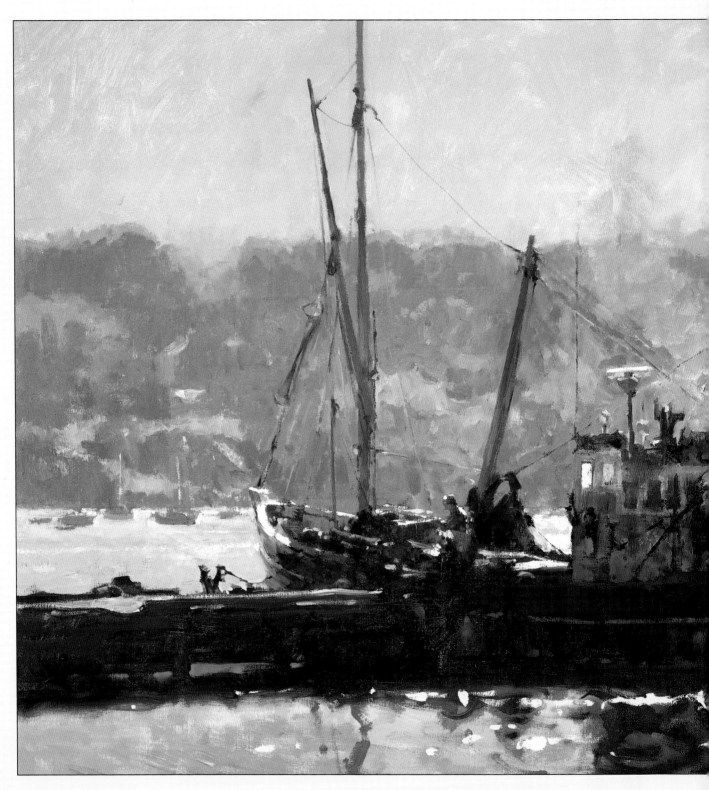

CELTIC BRILLIANCE, 24" × 30"

STUDIO PAINTING: EXPANDING YOUR HORIZONS

A successful *plein air* excursion may yield many great *pochade* studies that you would like to make into large studio versions, but a single brushstroke on a small panel may need ten strokes to portray it adequately on a large canvas. Here's where written notes, photographs and memories come in handy to create more organized statements.

Notes, Photos, Memories, Pochades

Reinforce memories by writing down your mood, sounds, smells, activity, temperature and colors when you are working in the field. Though photographs are no substitution for painting from life because they don't always show color accurately, they are great for providing necessary information for bigger pieces, such as details or poses. Learn to read your photos. A photo will expose for an average, not the darkest or lightest. The shadows will be too dense and dark or the lights will burn out. Skies look too blue, too dark or totally washed out. Bracketing on the high and low ends will help you read the shadows and subtle lights. It is better to have an overexposed shot, so you can see into the shadows.

Inside working from photos, even after a thousand *plein air* attempts, I find myself being too dictated by my slides. When working from photos it is a good idea to do a two-inch color study (a ten minute investment). You may soon get an idea where you need more information. It's best to have studies and photo reference when you enter the studio. The more I paint the less I use my photos and just rely on studies and memory.

It also helps to do studio paintings soon after *plein air* experiences, when the sense of place is fresh and familiar. Use the *pochade* for color notes and harmonies, taking more time indoors to compose, draw and design your canvas. Color harmonies and value relationships sometimes get off course when working with an outdoor study as reference, so use the same palette of colors. Tape thin plastic kitchen wrap or acetate around your *pochade* painting so that you can mix color notes and lay them right on the sketch to match colors. Establish these notes and relationships on your large canvas.

Create a more ordered statement retaining the freshness of the *pochade*, but don't be afraid to let your studio painting take a new direction. Just as nature is a departure point for you to interpret in paint, so should the sketch be for the larger version. Don't try to copy stroke for stroke. You will remain more excited during the painting process if you take the sketch and let it tell you which direction to go. Once you have the ability to judge color relationships accurately, develop your own technique.

Scrapbook
Cut up magazines and create a book of images you can browse through when you need a break. I find this very useful, and tend to look at these images more often than I would if I left them in the magazines.

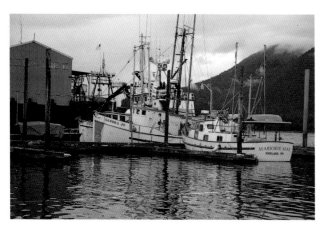

References
A *pochade* and daytime reference photo help create a night scene in the following demonstration.

NIGHTTIME ALASKA, 6" × 8"

AN IMPRESSIONISTIC NOCTURNE

1. UNDERPAINTING

Start with a warm brown wash over the whole canvas, which will vibrate through subsequent layers for a glowing, atmospheric sky. Then mass in the dark areas with warm purple. The paint is thin at this point.

IT'S YOUR CHOICE
Once you have the ability to judge color relationships accurately, attack your painting any way you choose. This will help you develop your own technique.

2. AN IMPRESSIONISTIC TOUCH

Even though this is a very large painting, using smaller brushes and strokes will give you an impressionistic touch. Impressionism is a practice of depicting natural appearances by means of dabs or strokes of colors in order to simulate the effects of light. Many kinds of light are bouncing around in this scene: some green, some orange. Some orange lamps are actually out of the picture frame. Knowing which direction the light source is coming from allows you to hit all the planes that face it with the influence of that light's color.

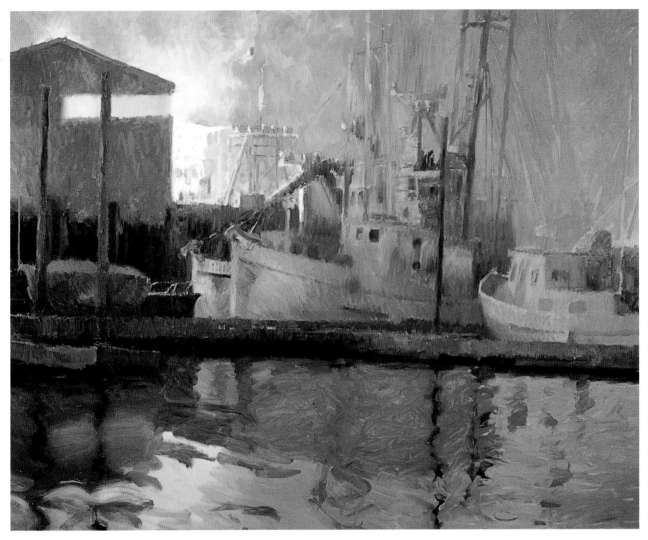

3. THE MYSTERY OF NIGHT

Cover the canvas with masses of shapes, keeping them soft—not too hard-edged—to give the less descriptive effect of what you might see at night.

Challenge yourself to do unfamiliar or difficult subjects. This will help you grow.

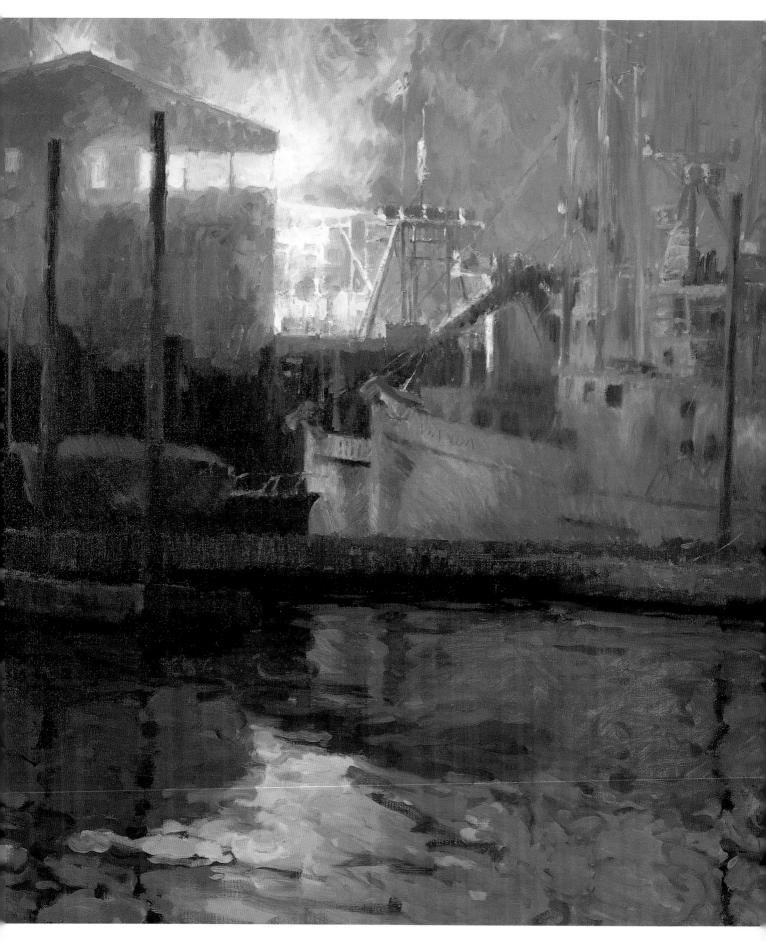

4. STEP BACK

So that you don't overwork, step way back to get a more distant view of the painting, turn the painting upside down, or view it in a mirror. Getting a different perspective helps you judge how far to go, because it lets you see your painting with a fresh eye. Make corrections if necessary.

ALASKAN HARBOR LIGHTS, 40″ × 50″

DEMONSTRATION

PUTTING IT ALL TOGETHER

1. A NEW START

Start by laying in abstract shapes of trees in a red wash. The sky will be quite warm. A wash of green undertone helps harmonize and tie together the foreground and background areas.

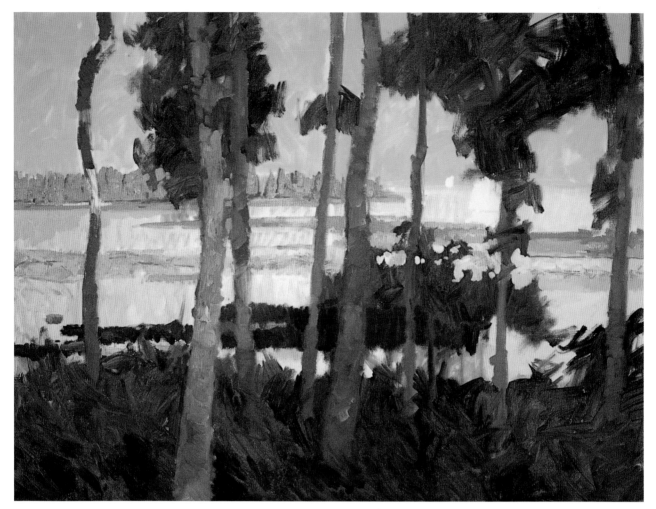

2. BLOCK IN THE BIG SHAPES

Mass in the trees a little beyond their intended final shapes with thin paint (the foliage is Winsor Green and Ultramarine Blue), letting some of the underpainting come through. Working thinner may give you more control and room for change, and this way you can carve into the trees with negative shapes. If you are too accurate now, it will hinder you later. The ground mass is a warmer green. Depict some leaf shapes on the edges of the silhouettes, giving the feeling of bushes and grasses. The sail is my lightest light; a mixture of white, Cadmium Yellow Pale and Alizarin Crimson thickly applied. On the light background it doesn't appear very bright.

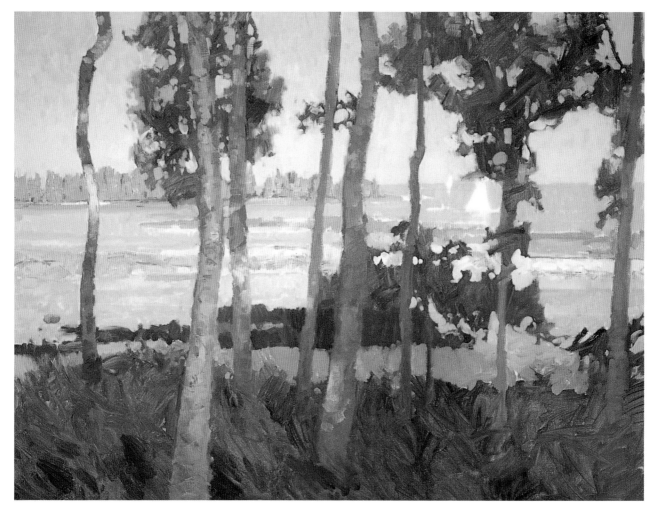

3. WORK ALL OVER THE CANVAS

Darken the water, surrounding the sail with a cool blue. This makes the sail appear lighter and warmer. Drag the brush to allow some of the red underpainting to remain, so that the water sparkles as if the wind were gently blowing across it. Many of the changes happening in the light family are just temperature changes; be aware that when you see a color change, you don't necessarily change the value. Compare greens to greens, reds to reds, blues to blues. For example, the bright green in the middle ground helps determine the correct color of the distant evergreens.

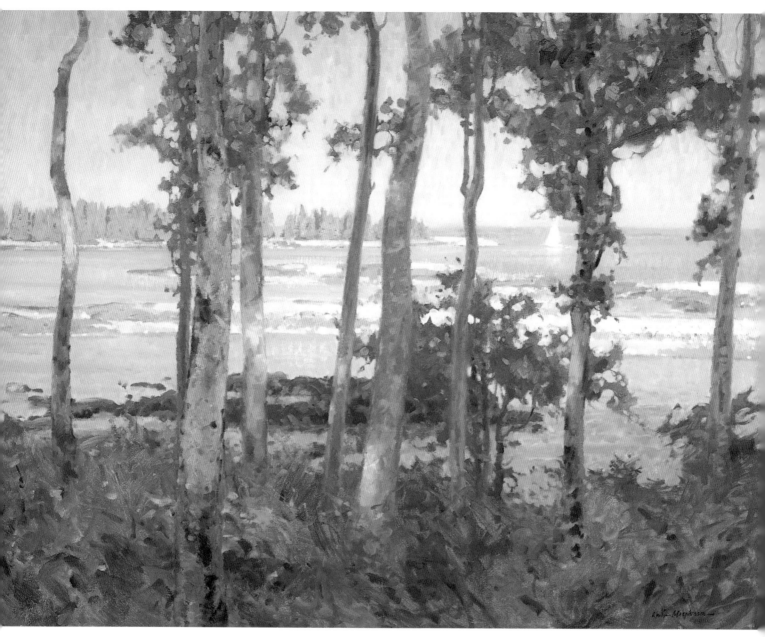

4. MAKE FINAL ADJUSTMENTS

Keep the sail quite soft, with one sharp edge. The sky is a large, flat area, so it needs color variety to give it sparkle and keep it alive. The tree trunks also need variation, form and texture. They get cooler as they reach for the sky, and their edges are painted to be more compatible with the background. Retain some of the dragged textures along the edges of the foliage to make the transition to the sky easier and softer. Check the painting from a distance, and make final adjustments.

SAILING THROUGH THE TREES,
36″×48″

Gallery of Studio Painting

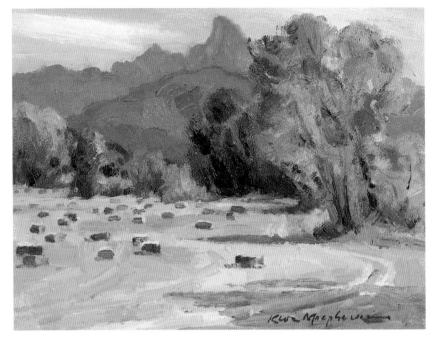

FALL BULLION, 6"×8" *pochade*

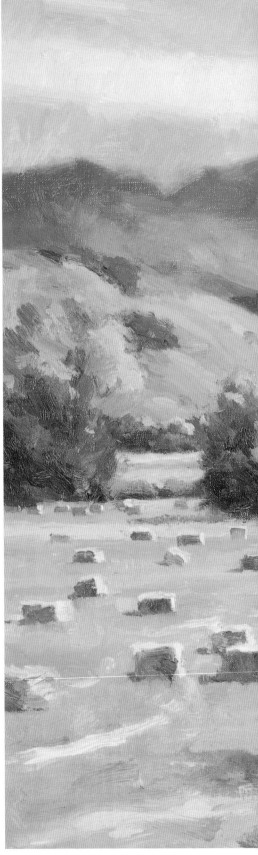

Rethinking a Composition

Once in the studio, I was able to rethink my composition. I decided that the Teton Peak was too centered and close to the top of the painting, so I added cloud cover and intensified the colors. By removing the landmark, I gave this piece a more universal appeal.

FALL BULLION, 20"×24"

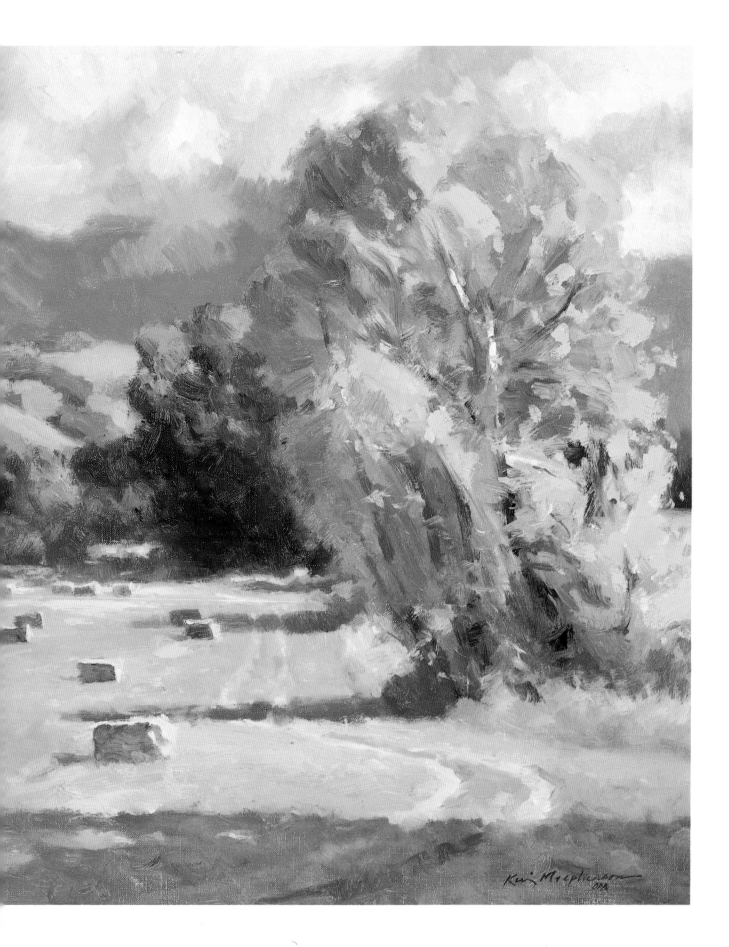

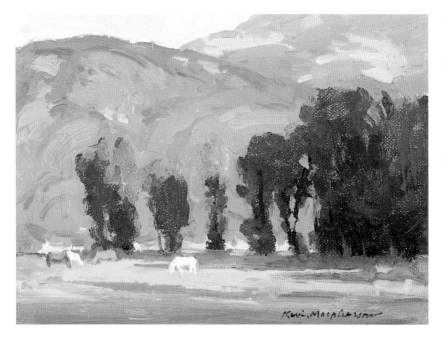

LONG MORNING SHADOWS,
6" × 8" pochade

Retaining Freshness

The larger studio version of this scene was done almost exclusively from the 6" × 8" color sketch. Plastic horses I keep in the studio helped me visualize their forms. The dark trees contrast with the airy quality of light on the distant mountains. The addition of snow on the mountains helps the eye move from foreground to background.

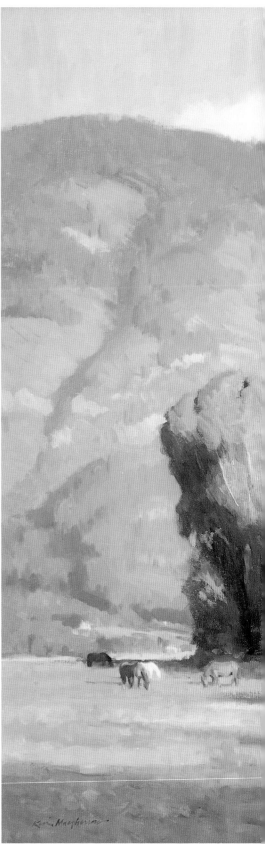

LONG MORNING SHADOWS, 40" × 50"

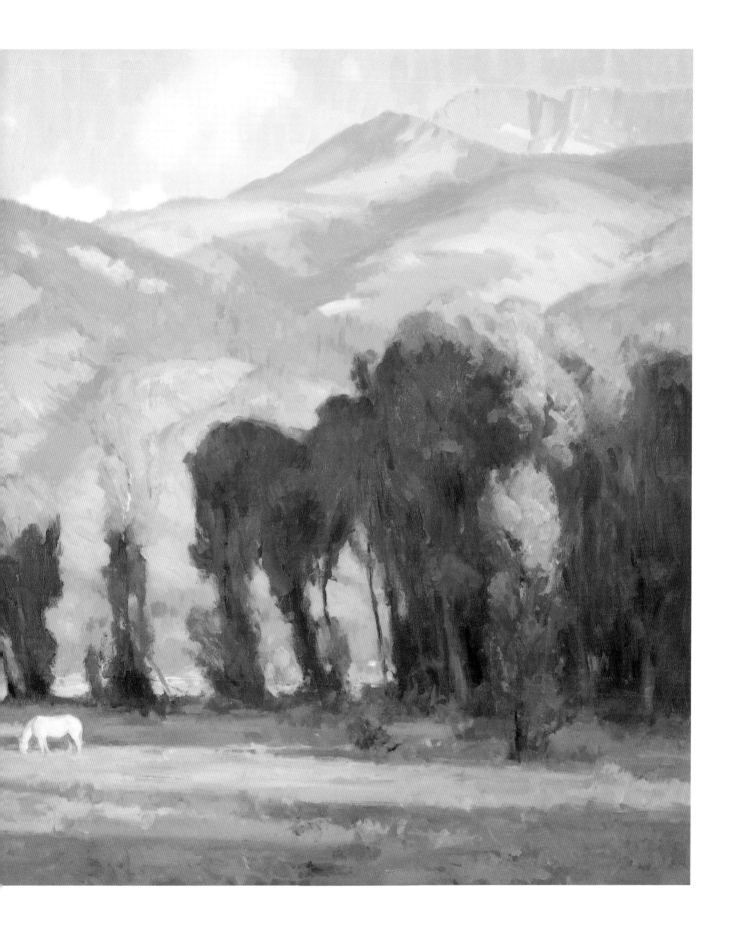

FULL MOON RISING, 6″ × 8″

Memory and Anticipation
On March 7, 1993, when I witnessed
the full moon rising at its closest point
to the earth in over a century I wanted
to paint it. Rushing back to my studio,
I jotted down the color combinations
on a 6″ × 8″ panel. Pleased with my
memory study, I began a larger compo-
sition, laying in the major masses of
color. Knowing that the scene would
change quickly, I went out again the
next day. This time I was prepared to
capture that moon and its warm light
on a larger format. The scene itself gave
me all the information I needed for the
piece you see on the facing page.

*Be responsible for your
growth. Work hard. Rewards
will come.*

FULL MOON RISING, 24"×24"

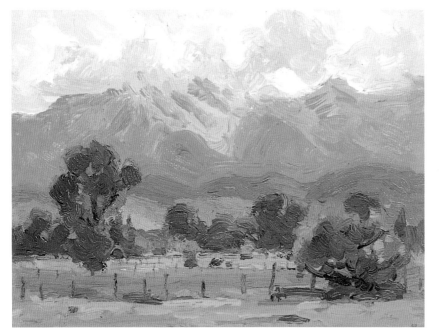

GRAZING BELOW THE MOUNTAINS,
6" × 8" *pochade*

The Feel of the Outdoors

I did this *pochade* on location in Bishop, California. The brilliant greens, the cloud-filled sky and the light beaming over the mountains were all caught in the small painting. It gave me the proper color harmonies necessary to work on the larger studio painting in addition to a photo reference for the gestures of the grazing sheep. Using the photo reference and the painting reference, I was able to create a large studio painting that feels like it was painted outdoors.

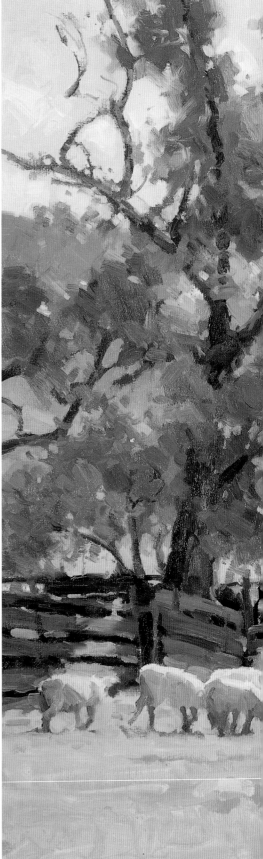

GRAZING BELOW THE MOUNTAINS,
30" × 36"

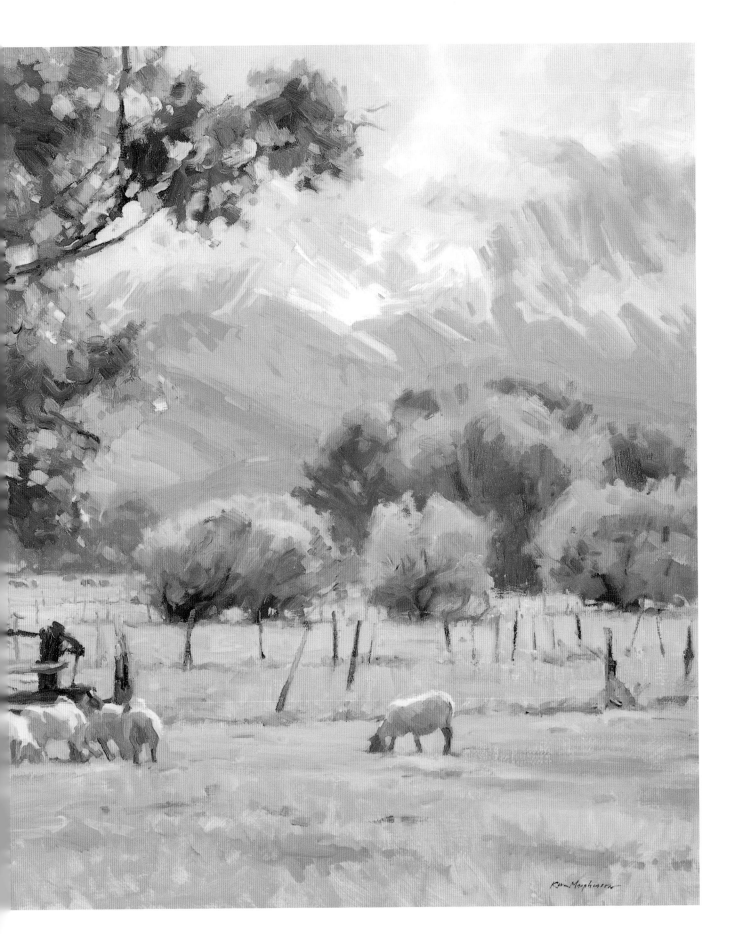

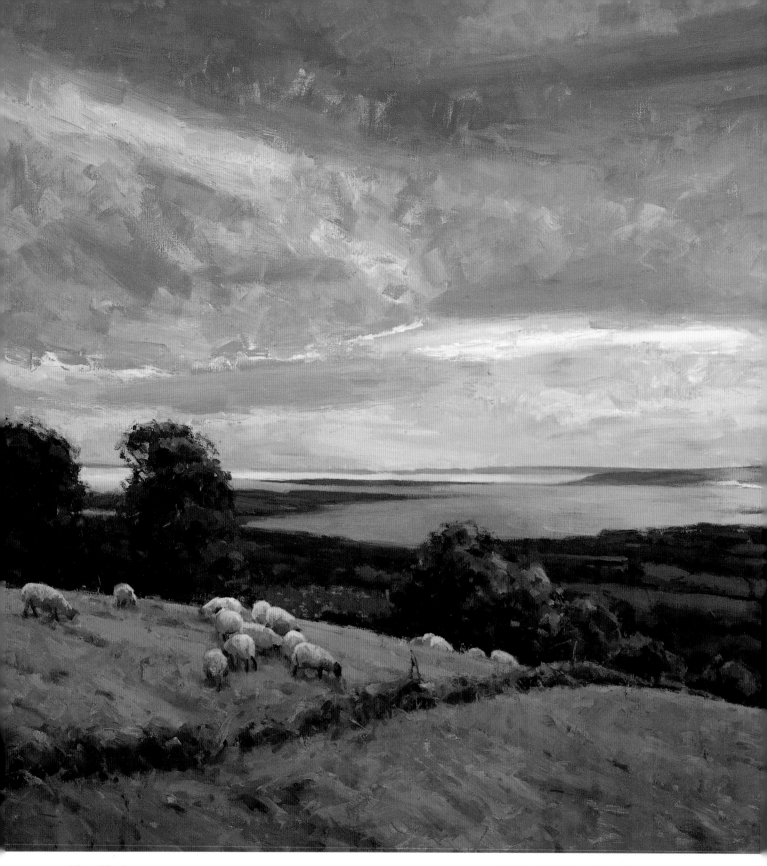

New Horizons
Each step you take when learning to paint will lead you to the next. Set your sights
and goals on higher levels.

YEATS COUNTRY, 40″×50″

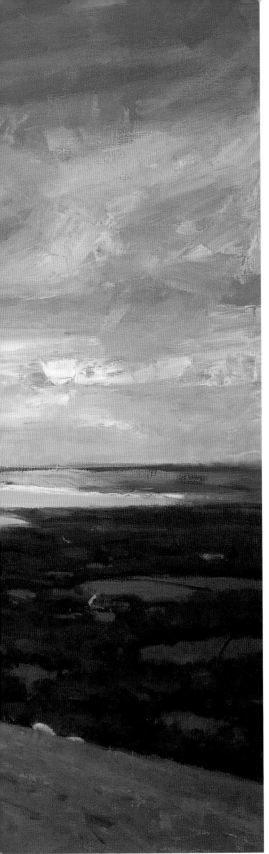

Conclusion: New Beginnings

Color is but one aspect of picture making. You must not only learn to see color accurately and mix it properly; you must also understand light and shade, and how to simplify shapes, composition, drawing, etc.

Use the general guidelines set forth in this book to analyze your paintings. They are here to help you, but not to lock you in. Analyze the works of great historical painters as well. If you look at examples of good fine art, your taste will continue to develop.

Critique your own art, as well as conducting critiques with fellow artists. Offer and accept constructive criticism. When I'm teaching, I identify different solutions to my students' various problems, which helps my work as well. I remember what I've told others and incorporate it into my own work. This type of interaction reinforces my convictions, and it can help you develop as an artist too.

There are no real conclusions in art, only new beginnings. As your painting skills improve, new chapters begin for you. Each time you meet a challenge, a fresh one follows. It never ends. But hard work pays off. You get a sense of accomplishment; perhaps even praise and financial success. This book will contribute to your development as an artist, a rewarding pursuit that can improve the quality of your life and bring joy into it. Life becomes more special, more miraculous. Anything that passes before your eyes is a possible subject. Beauty may appear anywhere, at any time. You just have to be ready for it.

YOU WILL IMPROVE

Set realistic goals throughout your painting career, and keep track of your progress. Date your paintings, then go back and visit earlier works from time to time. You may surprise yourself. There may be some things you couldn't do again, but overall you will improve.

Recommended Reading

Asaro, John. *Asaro: A New Romanticism*. Encinitas, California: Artra Publishing, Inc., 1991.

Balcomb, Mary N. *Nicolai Fechin*. Flagstaff, Arizona: Northland Publishing Co., 1975.

Bethers, Ray. *Pictures, Painters and You*. New York, London: Pitman Publishing Co., 1948.

Carlson, John F. *Carlson's Guide to Landscape Painting*. New York: Dover Publications, Inc., 1973. Originally published in 1929.

East, Sir Alfred, R.A. *Landscape Painting*. London, New York, Toronto, Melbourne: Cassell and Co., Ltd., 1921. Originally published in 1905.

Edwards, Betty. *Drawing on the Right Side of the Brain*. Los Angeles: Jeremy P. Tarcher, Inc., 1979.

Goldwater, Robert, and Marco Treves. *Artists on Art: From the 14th to the 20th Century*, 3rd ed. New York: Pantheon Books, 1974. Originally published in 1945.

Graves, Maitland. *The Art of Color and Design*, 2nd ed. McGraw Hill Book Co., Inc., 1951.

Hawthorne, Charles W. *Hawthorne on Painting*. New York: Dover Publications, Inc., 1960. Originally published in 1938.

Henri, Robert. *The Art Spirit*. Philadelphia: J.B. Lippincott Co., 1960. Originally published in 1923.

Hunt, William Morris. *On Painting and Drawing*. New York: Dover Publications, Inc., 1976. Originally published c. 1896–1898.

Levitan, Isaak Il'ich. *Levitan*. Leningrad: Aurora Art Publishers, c. 1981.

Loomis, Andrew. *The Creative Illustration*. New York: Viking Press, 1969. Originally published in 1947.

Payne, Edgar A. *Composition of Outdoor Painting*, 4th ed. Minneapolis: Payne Studios, Inc., c. 1985. Originally published in 1941.

Peel, Edmund, ed. *The Painter: Joaquin Sorolla*. New York: Sotheby's Publications, 1989.

Reid, James W. *Edward Seago: The Landscape Art*. London: Sotheby's Publications, 1991.

Ross, Denman Waldo, Ph.D. *On Drawing and Painting*. Boston and New York: Houghton Mifflin Company, 1912.

Russell, Chatham. *Chatham Russell: One Hundred Paintings*. Livingston, Montana: Clark City Press, 1990.

Sloan, John. *Gist of Art*, 3rd rev. ed. New York: Dover Publications, Inc., 1977. Originally published in 1939.

Stern, Arthur. *How to See Color and Paint It*. New York: Watson-Guptill Publications, 1984.

Swanson, Vern G. *Hidden Treasures: Russian and Soviet Impressionism 1930–1970s*. Scottsdale, Arizona: Fleischer Museum, 1994.

Town, Harold, and David P. Silcox. *Tom Thomson—The Silence and the Storm*. Toronto: McClelland and Stewart Inc., 1977.

Westphal, Ruth Lilly. *Plein Air Painters of California: The North*. Irvine, California: Westphal Publishing, c. 1986.

———. *Plein Air Painters of California: The Southland*. Irvine, California: Westphal Publishing, c. 1982.

Whyte, Jon, and E.J. Hart. *Carl Rungius: Painter of the Western Wilderness*. Vancouver, Toronto: Douglas & McIntyre, 1977.

ART BOOKS

Read art books over and over again. What doesn't make sense today may make sense down the road when you have more experience.

Index